U0361859

New Journey

COLLEGE ENGLISH
FOR ARTS
& HUMANITIES

新征程

艺术类大学英语
综合教程 3

总主编 谭 慧 张慧琴

主 编 郭锦霞 史亚娟

副主编 陈彬彬 张苹苹

编 者 曹 欢 仪 雪
　　　　徐艳秋 刘 华
　　　　罗振宁

清华大学出版社

北 京

内容简介

本套教材共四册，以艺术概论为核心内容进行编排，1~4册分别聚焦艺术的历史（艺术发生论）、艺术的创作（艺术本体论）、艺术与人生（艺术功能论）和艺术与社会（艺术接受论），分别对接通用英语基础和提高、学术英语初阶与中阶能力的培养目标。每册均含8个单元，各册第一单元都为该册核心内容的总体概览，后面7个单元分别围绕美术、音乐、舞蹈、电影、戏剧戏曲、服饰、建筑7大艺术门类的主题依次展开。每个单元的两篇文章分别从中外两个视角呈现其主题内容。本书为第三册。

读者目标：艺术类院校、综合性高校艺术类专业、师范类高校艺体类专业本科生和研究生；艺术英语学习爱好者。

图书在版编目（CIP）数据

新征程艺术类大学英语综合教程. 3 / 谭慧，张慧琴总主编；郭锦霞，史亚娟主编. —北京：清华大学出版社，2022.6

ISBN 978-7-302-60848-6

Ⅰ. ①新… Ⅱ. ①谭… ②张… ③郭… ④史… Ⅲ. ①艺术–英语–高等学校–教材 Ⅳ. ①J

中国版本图书馆 CIP 数据核字（2022）第 081465 号

策划编辑：刘细珍
责任编辑：刘细珍
封面设计：子 一
责任校对：王荣静
责任印制：丛怀宇

出版发行：清华大学出版社
　　网　　址：http://www.tup.com.cn, http://www.wqbook.com
　　地　　址：北京清华大学学研大厦 A 座　　　邮　编：100084
　　社 总 机：010-83470000　　　　　　　　 邮　购：010-62786544
　　投稿与读者服务：010-62776969, c-service@tup.tsinghua.edu.cn
　　质 量 反 馈：010-62772015, zhiliang@tup.tsinghua.edu.cn
印 装 者：北京盛通印刷股份有限公司
经　　销：全国新华书店
开　　本：185mm×260mm　　印　张：14.5　　字　数：312 千字
版　　次：2022 年 8 月第 1 版　　　　　　印　次：2022 年 8 月第 1 次印刷
定　　价：79.90 元

产品编号：095446-01

"新征程艺术类大学英语综合教程"系列教材

顾问委员会名单

（排名不分先后）

胡智锋
北京电影学院

黄　虎
中国音乐学院

张　尧
中国戏曲学院

姚　争
浙江传媒学院

许　锐
北京舞蹈学院

刘茂平
湖北美术学院

王丽达
中央音乐学院

鲍元恺
天津音乐学院

贺　阳
北京服装学院

沈义贞
南京艺术学院

于建刚
中国戏曲学院

〔英〕**Ashely Howard**
University for the Creative Arts, UK

〔美〕**Michael Zhang**
National Cash Register Co., USA

前 言

　　党的十九大报告强调"要全面贯彻党的教育方针，落实立德树人根本任务"。2018 年召开的全国教育大会进一步强调"不忘初心""四个回归""培养德、智、体、美、劳全面发展的社会主义建设者和接班人"。《高等学校课程思政建设指导纲要》（2020）明确提出要"抓住教师队伍'主力军'、课程建设'主战场'、课堂教学'主渠道'"；提出就专业教育课程而言，要"根据不同学科专业的特色和优势，深入研究不同专业的育人目标，深度挖掘和提炼专业教育课程知识体系中所蕴含的思想价值和精神内涵，拓展其广度、深度和温度……增加课程的知识性、人文性，提升引领性、时代性和开放性"。为全面落实上述指导意见，依据教育部制定的《大学英语教学指南》中界定的课程培养目标和要求，艺术英语专业分委会集合全国具有代表性的十余所艺术类院校的师资力量，在调查分析大学英语教学现状和预判未来发展趋势的基础上，参考《中国英语能力等级量表》的具体要求，精心策划和组织编写了"新征程艺术类大学英语综合教程"系列教材。

　　教材以艺术通识知识为纲，以促进中外艺术文化交流为旨，兼顾理论与实践，注重艺术类不同学科之间的交叉互融，既有历史全貌多角度的概览，也有新媒体与新艺术的呈现。

一、教材特色

1. 融入式艺术素养

　　基于跨学科理念，融多种艺术门类为一体，将艺术的历史、艺术的创作、艺术与人生、艺术与社会、艺术与情感等融会贯通于整套教材中，环环相扣，纵横交错，提升学生的艺术素养，注重学生跨文化交际能力的培养。

2. 浸入式课程思政

所选课文主题强调社会主义核心价值观。在语法、翻译、阅读、写作等练习中均有效融入思政元素，培养学生的创新思维、思辨能力、家国情怀、国际视野，增强学生的文化自信，注重中华艺术文化对外交流和传播能力的提升。

3. 个性化分级教学

依据全国艺术类专业本科生的普遍英语起点水平进行分级编排。在内容层面，1–4 册由浅入深分别聚焦不同领域；在语言层面，分级的主要依据是词汇量和课文的 Flesch 难度。难易梯度的安排贴合艺术类院校学生的实际需求，具有个性化、可选择性的优势。

4. 导向式语言学习策略

教学内容的设计围绕不同艺术类话题与情景而展开，强调"做中学"。同时讲授听说读写译等相应的语言学习策略，在培养学生英语技能的同时，提升其语言综合运用能力和学习能力。

5. 养成式语法写作技能操练

采用"养成习惯的技巧"(habit-forming technique)，帮助学生在循序渐进中学习、操练和习得。融枯燥的语法于多样化的练习中，通过语法点在听、说、读、写、译等不同练习中的复现，使学生有效掌握语法要点和相关句型的交际功能，提升其语言交际能力；融写作技巧于多元的实操内容中，通过艺术批评写作、求职信、数据表格描述、艺术类研究计划等应用文体的反复操练，提高学生的语言实践能力。

6. 预构成语块有效习得

运用语料库，通过真实例句与练习，科学选择并指导学生有效习得预构成语块，避免其孤立硬背生词表，帮助他们培养语感，提升其英语表达的地道性和流利性。

二、教材结构

本系列教材每册设 8 单元，每单元由 Reading A 和 Reading B 及配套练习组成。横向上，1–4 册的选文均以艺术概论的核心内容为准绳，力图使学生掌握艺术领域的通识知识以及艺术英语的常用语汇。纵向上，1–4 册纵向贯穿，由浅入深，分别聚焦艺术的 4 个不同层面。各册第 1 单元选文旨在提纲挈领地介绍该册的核心聚焦领域，后面 7 个单元均按照 7 大艺术门类（美术、音乐、舞蹈、电影、戏剧戏曲、服饰、建筑）依次安排主题，各单元的 Reading A 和 Reading B 则分别围绕该主题从中外两个不同视角进行选材。1–4 册总体安排如下：

册　数	聚焦领域	能力培养
第 1 册	艺术的历史（艺术发生论）	通用英语能力（基础）
第 2 册	艺术的创作（艺术本体论）	通用英语能力（提高）
第 3 册	艺术与人生（艺术功能论）	学术英语能力（初阶）
第 4 册	艺术与社会（艺术接受论）	学术英语能力（高阶）

总之，本系列教材注重跨文化交际能力的培养，融入课程思政元素，彰显艺术类不同学科互通共融之特色。在具体内容的编排上层次清晰，分级科学，基于《中国英语能力等级量表》确定篇章的长度和难易度，循序渐进，符合语言学习的基本规律。同时，充分考虑篇章的思想性、语言规范性、知识性、趣味性、文化性、人文性、时代性、可读性与启发性等；注重题材的多样化，从文学作品到科学小品文，再到经典寓言与名篇演讲，兼顾选材的丰富性和内容价值。旨在丰富和创新艺术类大学英语教学内容，培养通晓中外美术、音乐、舞蹈、电影、服饰、戏剧戏曲和建筑的艺术类国际化特色人才。

由于编写团队水平所囿，书中疏漏在所难免，敬请广大读者批评指正。

本书编写组

目录

Learning Objectives

Students will be able to:

- ⊘ understand the vocabulary regarding art and artist life;
- ⊘ describe the reciprocal shaping of artist and art;
- ⊘ gain the knowledge concerning the appreciation of artworks;
- ⊘ write a line graph essay.

Unit 1

Art and Life

Lead-In

Task 1 Exploring the Theme

Watch a short video clip and fill in the blanks.

At the New York Hall of Science in Queens environmental sustainability is taught in this 1) _____ display, the connected-world exhibit which features 20 2) _____ that light up the walls and floor. At the American Revolution Museum at Yorktown a Virginia Museum set to open next year. A 4D movie will be one of the centerpieces. Visitors 3) _____ the eight-minute film will see 4) _____ actors and special effects, smell the aroma piped in gunpowder and feel their seats 5) _____ when cannons are fired on the screen.

The National World War II Museum in New Orleans has a 6) _____ immersive film. That's shown on a 130-foot-wide screen and it 7) _____ moving sets: snow, wind and 8) _____ seats. Smaller museums like the Illinois Holocaust Museum and Education Center in Skokie are 9) _____ his test sites for new ideas like this interactive 10) _____ of Penshurst Gutter, a Holocaust survivor.

Task 2 Brainstorming

Work with your classmates and complete the following tasks.

1) List some artists and notable artworks.

2) Talk about an artist you know regarding the mutual relations between the artist and his or her life experience.

Task 3 Building Vocabulary

Discuss with your classmates, and try to describe the following words and phrase in English.

> auction house portrait sculpture installation ceremony

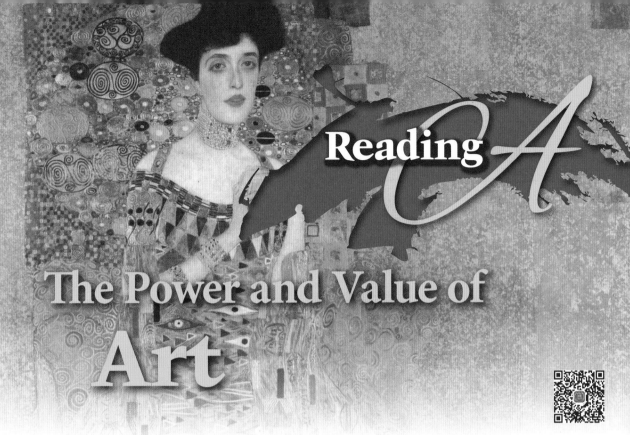

Reading A

The Power and Value of Art

1 On November 8, 2006 at Christie's **auction** house in New York City, the most expensive item for sale that evening was a portrait, *Adele Bloch-Bauer II*[1], painted in 1912 by the Austrian artist Gustav Klimt[2]. It sold for $87.9 million. Klimt made a comfortable living from painting portraits of the wives and sisters of wealthy Austrian businessmen, but in his own lifetime he was certainly never paid anything like the enormous sum for which his portrait of Mrs. Bloch-Bauer sold in 2006. One reason for the painting's increase in price was its **controversial** history. In 1938 it had been **looted** by the Nazis, who had occupied Austria, and the work later became the subject of a **lawsuit** by the **heirs** of the Bloch-Bauer family.

2 When we read that some works of art sell for large amounts of money while others do not, we might ask ourselves why such a high financial value is placed on a single work. Works of art by famous artists of the past tend to be valued at

auction *n.* 拍卖

controversial *adj.* 引起争论的；有争议的

loot *v.*（暴乱、火灾等后）打劫；抢劫；劫掠

lawsuit *n.* 诉讼；起诉

heir *n.* 继承人；后嗣

1 《阿黛尔·布洛赫 – 鲍尔肖像（2）》，绘于 1912 年，古斯塔夫·克里姆特（Gustav Klimt）最著名的作品之一。画面主角阿黛尔·布洛赫 – 鲍尔女士（Adele Bloch-Bauer）是克里姆特的赞助人。

2 古斯塔夫·克里姆特（1862–1918），奥地利知名象征主义画家，代表作品有《金鱼》《阿黛尔》《阿黛尔·布洛赫 – 鲍尔肖像》《莎乐美》等。

a high price, especially if they are very rarely available. In our modern society art is often valued by its sale price, but there are many other ways of valuing it. When we visit art museums, we see artworks **displayed** inside glass cases or at a distance from the viewer, who must not touch. The care to **preserve** them in perfect condition is an indication that these works are highly valued. Sometimes a work is valued because it is very old or rare, or indeed unique.

display *v.* 陈列；展出；展示

preserve *v.* 保护；维护；保留

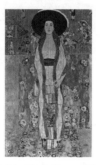

Adele Bloch-Bauer II by
Gustav Klimt, 1912

Gustav Klimt (1862–1918)

3　In many societies, however, artworks were not made to be sold or displayed where they cannot be touched. As we have seen, the Japanese made fine tea bowls. These bowls were to be used as part of a ceremony, and, of course, excellent tea. The tea bowl was valued because it formed part of a **ritual** that had social and spiritual significance. Similarly, in the African art section of many museums we can see masks displayed. They were originally made to form part of a **costume** that, in turn, was used in a ceremony involving other costumed figures, music, and dancing. In other words, the mask often had some kind of spiritual or magic significance for its original creators: but they would have regarded it as holding this value only when used as **intended**, not when displayed in isolation in a museum.

ritual *n.* 宗教仪式；程序；仪规；礼节

costume *n.* （戏剧或电影的）戏装；服装

intend *v.* 打算；计划；想要；意指

The Girl with a Pearl Earring by Johannes Vermeer, 1665

4　An essential reason why we value art is that it has the power to **confront** us with ideas and feelings about the human condition. Art is

confront *v.* 使……无法回避；降临于

a powerful means of self-expression because it enables us to give physical shape or form to thoughts and **sensations**. Marc Quinn[1] is a British contemporary **visual** artist whose work include **sculpture**, **installation**, and painting. His art often not only focuses on the body but also uses his actual body as a basis for making the work. Since 1991, Quinn has been making a life-size self-portrait of his head every five years. Each time he used between eight and ten **pints** of his blood, **cast** and then frozen by means of a refrigerating device. These works have an **immediate** impact, partly because they are made of blood. We instinctively relate blood to the life force, on which we all depend for survival. Looking at *Self*, we naturally contemplate our own mortality and our fear of it. *Self* is powerful too because when we look at such a raw portrait we instinctively compare its effect on us with how we appear to other people. It makes us think about self-image: who we really are, and who we think ourselves to be. The use of the head and face allows us intimately connected to our sense of identity.

5 So we see that price is not the only, or the most important, measure of the value of an artwork. We might place a high value on a work because it is **aesthetically** pleasing or because its creation involved great skill. This can be true even if there is no possibility of our owning it. Many museums organize large exhibitions of the work of famous artists because they know that great numbers of people will pay to see the work. In 2012, for example, 758,000 people visited an exhibition of the work of various Old Master artists, including Johannes Vermeer's[2] famous *Girl with a Pearl Earring*[3], as well as paintings by

sensation *n.* 轰动；哗然；引起轰动的人（或事物）

visual *adj.* 视觉的；视力的

sculpture *n.* 雕像；雕塑品；雕刻品

installation *n.* 现代雕塑装置（除物体外的声、光等元素）

pint *n.* 品脱（容量单位，为 1/8 加仑，在英国等国家约合 0.568 升，在美国约合 0.473 升）

cast *v.* 浇铸；铸造

immediate *adj.* 接近的；附近的；紧接的

aesthetically *adv.* 审美地；美学观点上地

1 马克·奎安（1964– ），英国艺术家，擅长绘画及雕塑。其最早为公众所知的作品为《自我》(*Self*)：1991 年，他用约 5 个月时间储存了 4.5 升自己的冷冻血液作为材质，雕塑他自己的头像，2005 年这件作品以 150 万英镑的价格被卖给一位美国的收藏家。

2 约翰内斯·维米尔（1632–1675），荷兰绘画大师。

3 《戴珍珠耳环的少女》，创作于 1665 年，约翰内斯·维米尔的重要成就，现藏于荷兰海牙毛利斯博物馆。画中女子身份不详。

Rembrandt Harmenszoon van Rijn[1], Frans Hals[2], and Anthony van Dyck[3] at the Tokyo National Museum, Japan.

6　Artworks can also acquire great religious, cultural, or political significance. Perhaps the most **enduring** example of such a work is the painting of the *Virgin of Guadalup*[4]. According to Catholic tradition, in December 1531 the Virgin appeared several times, first on Tepeyac Hill[5], then outside Mexico City[6], to an **indigenous** peasant, Juan Diego, and miraculously imprinted her own image on his cloak made of **cactus fiber**. Historical evidence, however, suggests that the Virgin was painted in **tempera** on **linen**, probably by an indigenous artist. Whichever account of the painting's origin one accepts, the Virgin is seen, in the words of the Bible, "clothed with the sun, with the moon under her feet", but she has the dark skin of an indigenous woman, emphasizing the Virgin's role as the protector of her "Indian" kingdom in Mexico. The Virgin became the symbol of the Mexican nation not just for Mexicans of Indian **descent** but also for all the citizens of the country, and not only for **devout** Catholics. She now appears in countless paintings and in churches throughout the country.

(926 words)

(Adapted from: DeWitte D. J., Larmann R. M., and Shields M. K. *Gateways to Art: Understanding the Visual Arts*. New York: Thames & Hudson, 2012.)

enduring *adj.* 持久的；耐久的

indigenous *v.* 本地的；当地的；土生土长的

cactus fiber 仙人掌纤维

tempera *n.* 蛋彩画；蛋彩画颜料（用颜料与鸡蛋和水调和而成）

linen *n.* 亚麻布

descent *n.* 血统；祖籍；祖先；出身

devout *adj.* 笃信宗教的；虔诚的

1　伦勃朗·哈尔曼松·凡·莱因（1606–1669），欧洲 17 世纪最伟大的画家之一，也是荷兰历史上最伟大的画家。

2　弗兰斯·哈尔斯（1558–1666），17 世纪荷兰画派的奠基人和最杰出的肖像画大师之一。

3　安东尼·凡·戴克（1599–1641），法兰德斯巴洛克艺术家，英国领先的宫廷画家。

4　《瓜达卢佩圣母像》。

5　特佩亚克山，位于墨西哥城内。

6　墨西哥城，墨西哥合众国的首都。

Part I Understanding the Text

Task 1 Global Understanding

1. What is the main idea of this article?

2. Write down the key idea of each paragraph below.

Paragraph 4: _____

Paragraph 5: _____

Paragraph 6: _____

Task 2 Detailed Understanding

1. Read the text again and choose the best answer to each question below.

1) What is the main reason for the high value of Gustav Klimt's painting *Adele Bloch-Bauer II*?

 A. Because it was created by Gustav Klimt.

 B. Because it is now owned by the Bloch-Bauer family.

 C. Because it once earned much money for Gustav Klimt.

 D. Because it was once owned by the Nazis and now eventually returned to the Bloch-Bauer family.

2) How can we as ordinary viewers infer the value of a specific artwork according to Paragraph 2?

 A. We can infer from where and how the artwork is displayed in the museum.

 B. We can infer from the popularity of the artwork.

 C. We can infer from the appearance of the artwork.

 D. We can infer from our knowledge about the artwork.

3) What is the essence of art?

 A. Its practical function in our daily life.

 B. Its power to meet the need of human expression.

 C. Its religious significance.

 D. Its aesthetic pleasure.

2. Answer the following questions according to the text.

1) What is the meaning of "the subject of a lawsuit" in Paragraph 1?

2) According to the text, what is the original use of those African masks in Paragraph 3?

3) How do you understand the sentence "The use of the head and face allows us intimately connected to our sense of identity." in Paragraph 4?

Part II Building Language

Task 1 Key Terms

The words on the left are related to art. Match each of them with its explanation on the right.

1) portrait
A a public event at which things are sold to the person who offers the most money for them

2) visual
B a piece of modern sculpture

3) cast
C a kind of cloth that is made from a plant called flax

4) display
D to shape hot liquid metal

5) installation
E a painting, drawing or photograph of a person, especially of the head and shoulders

6) linen
F the clothes worn by actors in a play or film/movie

7) costume
G relating to or using sight

8) auction
H a kind of paint in which the color is mixed with egg and water

9) preserve
I a series of actions that are always performed in the same way, especially as part of a ceremony

10) ritual
J to show sth. to people

11) sensation
K belonging to a particular place rather than coming to it from somewhere else

12) indigenous
L to make sure that sth. is kept in its original state

13) tempera
M sb. or sth. that causes great excitement or interest

Choose the correct word from the box below to complete each of the following sentences. Change the form where necessary.

enormous	item	occupy	heir	aesthetic
isolate	spirit	endure	instinctive	involve
unique	finance	preserve	contemporary	mortal

1) Pointillism (点画法) is a technique of painting that _____ the application of paint in carefully placed dots of pure unmixed color.

2) Although most people, I believe, would wish to _____ this art, I'm afraid that tourism is another reason why the art is disappearing.

3) We carefully labeled each _____ with the contents and the date.

4) With the young unable to afford to leave home and the old at risk of _____, more families are choosing to live together.

5) Hearing such stories is not sufficient for younger children to form _____ memories.

6) The project implies a(n) _____ investment in training.

7) A statue which is _____ pleasing to one person, however, may be disliked by another.

8) Problems at work continued to _____ his mind for some time.

9) Painting has a strong faith connection for the artist, Deborah Nell, who considers the act of making art itself as _____ experience.

10) Humans _____ seek structures that will shelter and enhance their way of life.

11) Everyone's fingerprints are _____.

12) She has written a lot of _____ music for people like Whitney Houston.

13) The study also demonstrated a direct link between obesity and _____.

14) She accused him of ruining her _____ with his taste for the high life.

15) At present, a male royal _____ would always accede to the throne ahead of an older sister.

Task 3 **Grammar and Structure**

Complete the following sentences by translating the Chinese given in brackets into English. You should use the proper verb forms, either present participle (*-ing*) or past participle (for instance, *-ed* as the regular form), to complete the sentences.

1) Jim was attending the lecture with _____ (所有注意力都在上面).

2) The pop singer didn't turn up, _____ (让他的歌迷非常失望).

3) _____ (在国外长大), he knows little about his parents' hometown.

4) _____ (所有学生都坐下后) , the lecture began.

5) _____ (时间允许的话), we will discuss about the problems you address.

Part III Translation

1. Translate the following sentences into Chinese.

1) When we visit art museums, we see artworks displayed inside glass cases or kept at a distance from the viewer.

2) In our modern society art is often valued by its sale price, but there are many other ways of valuing it.

3) They would have regarded the mask as holding this value only when used as intended, not when displayed in isolation in a museum.

4) *Self* is powerful because when we look at such a raw portrait we instinctively compare its effect on us with how we appear to other people.

5) We might place a high value on a work because it is aesthetically pleasing or because its creation involved great skill.

2. Translate the following sentences into English.

1) 那个宋代花瓶创下了中国艺术品拍卖价格的新纪录。

2) 隐含在他思想中的艺术价值取向，对中国艺术，尤其是对传统绘画艺术的审美走向产生了深刻的影响。

3) 黄公望的《富春山居图》(*Dwelling in the Fuchun Mountains*)是一幅有名的山水画，反映了人与自然和谐统一的哲学思想。

4) 收藏品很难估价。许多因素决定了其标价，包括藏品品相、买卖双方个人兴趣以及市场潮流。

5) 三个小时的授课和交流，让孩子们亲身体验了中国传统文化的魅力，并了解了这些中国艺术的来源。

Reading B

On Art and Artists

1 There is indeed no such thing as Art. There are only artists. Once these were men who took colored earth and **roughed out** the forms of a **bison** on the wall of a cave; today they buy their paints, and design posters for the underground; they did many things in between. There is no harm in calling all these activities art as long as we keep in mind that such a word may mean very different things in different times and places, and as long as we realize that Art with a capital A has no existence. For Art with a capital A has come to be something of a **bogey** and a **fetish**. You may crush an artist by telling him that what he has just done may be quite good in its own way, only it is not "Art". And you may **confound** anyone enjoying a picture by declaring that what he liked in it was not the Art but something different.

2 Actually there are not any wrong reasons for liking a statue or a picture. Someone may like a landscape painting because it reminds him of home, or a portrait because it reminds him of a friend. All of us, when we see a painting, **are bound to** be reminded of a hundred-and-one things which influence our

rough out 画……的草图；草拟

bison *n.* 野牛

bogey *n.* （无缘无故）使人害怕的事物

fetish *n.* 迷恋；癖好

confound *v.* 使困惑惊讶；使惊疑

be bound to 一定会；很可能会

likes and dislikes. As long as these memories help us to enjoy what we see, we need not worry. It is only when some irrelevant memory makes us prejudiced, when we instinctively turn away from a magnificent picture of an **alpine** scene because we dislike climbing, that we should search our mind for the reason of the **aversion** which **spoils** a pleasure we might otherwise have had. There are wrong reasons for disliking a work of art.

alpine *adj.* 高山的；（尤指中欧）阿尔卑斯山的

aversion *n.* 厌恶；憎恶

spoil *v.* 糟蹋；毁掉；破坏；搞坏

3 Most people like to see in pictures what they would also like to see in reality. This is quite a natural preference. We all like beauty in nature, and are grateful to the artists who have preserved it in their works. When the great Flemish painter Peter Paul Rubens[1] made a drawing of his little boy, he was proud of his good looks. He wants us, too, to admire the child. But this bias for the pretty and engaging subject is apt to become a **stumbling** block if it leads us to reject works which represent a less appealing subject. The great German painter Albrecht Dürer[2] certainly drew his mother with as much devotion and love as Rubens felt for his **chubby** child. His truthful study of **careworn** old age may give us a shock which makes us turn away from it—and yet, if we fight against our first **repugnance** we may be richly rewarded, for Dürer's drawing in its tremendous sincerity is a great work. In fact, we shall soon discover that the beauty of a picture does not really lie in the beauty of its subject matter.

stumble *v.* 跌跌撞撞地走；蹒跚而行

chubby *adj.* 胖乎乎的；圆胖的；丰满的

careworn *adj.* 忧虑憔悴的

repugnance *n.* 嫌恶；恶心；强烈的反感

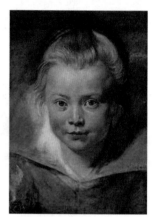

Ein Kinderkopf by Peter Paul Rubens, 1618

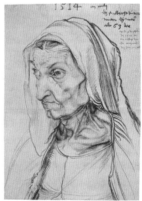

Portrait of the Artist's Mother by Albrecht Dürer, 1514

1 彼得·保罗·鲁本斯 (1577–1640)，佛兰德斯画家，巴洛克画派早期的代表人物。

2 阿尔布雷特·丢勒 (1471–1528)，德国文艺复兴时期的代表画家，以油画和版画见长。

4 The trouble about beauty is that tastes and standards of what is beautiful vary so much. What is true of beauty is also true of expression. In fact, it is often the expression of a figure in the painting which makes us like or **loathe** the work. Some people like an expression which they can easily understand, and which therefore moves them profoundly. When the Italian seventeenth-century painter Guido Reni[1] painted the head of Christ on the cross, he intended, no doubt, that the beholder should find in this face all the agony and all the glory of the passion. The feeling it expresses is so strong and so clear that copies of this work can be found in simple **chapels** and far-away farmhouses where people know nothing about "Art". But even if this intense expression of feeling appeals to us, we should not, for that reason, turn away from works whose expression is perhaps less easy to understand. We must first learn the painter's methods of drawing to understand his feelings. When we have come to understand these different languages, we may even prefer works of art whose expression is less obvious than Reni's.

loathe *v.* 讨厌；厌恶

chapel *n.* （学校、监狱、私人宅院等基督教徒礼拜用的）小教堂

5 But here people are often brought up against another difficulty. They want to admire the artist's skill in representing the things they see. What they like best is paintings which look "like real". I do not deny for a moment that this is an important consideration. The patience and skill which go into the faithful **rendering** of the visible world are indeed to be admired. Great artists of the past have devoted much labor to works in which every tiny detail is carefully recorded. Dürer's watercolor study of a hare is one of the most famous examples of this loving patience. But who would say Rembrandt's drawing of an elephant is necessarily less good because it shows fewer details?

rendering *n.* 表现；表演；翻译

6 People who like pictures to look "real" are even more **repelled** by works which they consider to be incorrectly drawn, particularly when they belong to a more modern period. **Paradoxically**, everyone who has ever seen a Disney film knows

repel *v.* 使厌恶、反感；抵制；击退

paradoxically *adv.* 自相矛盾地；似是而非地

1 圭多·雷尼 (1575–1642)，意大利巴洛克画家。

that it is sometimes right to draw things otherwise than they look, to change and distort them in one way or another. Mickey Mouse does not look very much like a real mouse, yet people do not complain. But if a modern artist draws something in his own way, he is apt to be thought a **bungler** who can do no better. Now, whatever we may think of modern artists, we may safely credit modern artists with enough knowledge to draw "correctly". If they do not do so their reasons may be very similar to those of Mr. Disney.

bungler *n.* 笨拙的人

7 We **are** all **inclined to** accept **conventional** forms or colors as the only correct ones. Otherwise, we dislike and criticize works of art. We need to know "work of art" are not the results of some mysterious activity, but objects made by human beings for human beings. Let us remember that every one of their features is the result of a decision by the artist—that he may have **pondered** over them and changed them many times, that he may have wondered whether to leave that tree in the background or to paint it over again, that he may have been pleased by the lucky stroke of his brush which gave a sudden unexpected brilliance to a sunlit cloud, and that he put in these figures **reluctantly** at the insistence of a buyer. For most of the paintings and statues which are now strung up along the walls of our museums and galleries were not meant to be displayed as Art. They were made for a definite occasion and a definite purpose which were in the artist's mind when he set to work.

be inclined to 有……
倾向；很可能

conventional *adj.* 传统的；习惯的

ponder *v.* 沉思；考虑；琢磨

reluctantly *adv.* 不情愿地；勉强地

(1122 words)

(Adapted from: Gombrich E. H. *The Story of Art*. New York: Phaidon Publishers Inc., 1950.)

Part I Understanding the Text

Task 1 Global Understanding

1. Read the text and identify the main ideas.

1) How does the author consider an artwork good or not?

2) What factors contribute to artists for their artworks?

2. Write down the main idea of each paragraph below.

Paragraph 3: _____

Paragraph 4: _____

Paragraph 6: _____

Task 2 Detailed Understanding

1. Answer the following questions according to the text.

1) How do you understand "a hundred-and-one things which influence our likes and dislikes" in Paragraph 2?

2) What is the implication of the statement "the beauty of a picture does not really lie in the beauty of its subject matter" in Paragraph 3?

3) How would you interpret the statement "'work of art' is made by human beings for human beings" in Paragraph 7?

2. Discuss the following questions with your partner.

1) In what way did the author take an artist's works as the results of his or her own decision?

2) Comparing Ruben's chubby child and Dürer's careworn mother, which do you prefer?

3) Why did the author say that there is no "Art" with a capital A but "artist"?

Part II Building Language

Task 1 **Key Terms**

The words on the left are related to art. Match each of them with its explanation on the right.

1) statue **A** a person or object selected by an artist for graphic representation

2) beauty **B** graphic art consisting of an artistic composition made by applying paints to a surface

3) picture **C** a water-based paint (with water-soluble pigments)

4) watercolor **D** representation of forms or objects on a surface by means of lines

5) artist **E** the quality of being pleasing to the senses or to the mind

6) landscape **F** a figure of a person or an animal in stone, metal, etc.

7) gallery **G** a person who creates works of art

8) scene **H** everything you can see when you look across a large area of land, especially in the country

9) subject **I** a room or a series of rooms where works of art are exhibited

10) drawing **J** the visual percept of a region

Choose the correct word or phrase from the box below to complete each of the following sentences. Change the form where necessary.

crush	be bound to	magnificent	confound	prejudice
tremendous	prefer	agony	reward	represent
render	detail	patience	paradox	be inclined to

1) These negative feelings are taught and reinforced by the _____ persons' peer groups.

2) Her bruises on the wrists have faded, but she is still suffering the _____.

3) Many experts advocate _____ children for their good behavior.

4) Can you give me more _____ information, such as its color, size and the trademark?

5) _____, the less she ate, the fatter she got.

6) I _____ go to the beach tomorrow if it doesn't rain.

7) She is very _____ with young children.

8) Putting on an opera is a(n) _____ enterprise involving literally hundreds of people.

9) Let's look at the effect this _____ can have by looking at some examples.

10) The beauty of the city consists in its _____ buildings.

11) The detectives were _____ by the puzzling riddles left behind by the kidnaper.

12) Making an investment in education _____ yield us great results.

13) To make a chef salad, he puts some vegetables into a bowl and _____ with a potato masher.

14) His originality as a painter lies in his _____ of light.

15) This phrase may well have been a(n) _____ of a popular Arabic expression.

Task 3 Grammar and Structure

Complete the following sentences by translating the Chinese given in brackets into English as attributive clauses.

1) There was a machine in the kitchen _____ (半小时就可以榨取 200 个橙子的果汁).

2) The conference was postponed, _____ (这正是我们希望的).

3) Hangzhou has made it into the top ten cities _____ (旅游者最想参观的).

4) The old painting in your attic _____ (你想扔掉的) could be worth a fortune.

5) Impressionism is a genre of art _____ (十九世纪后期非常受欢迎).

Part III Translation

1. Translate the following sentences into Chinese.

1) There is no harm in calling all these activities art as long as we keep in mind that such a word may mean very different things in different times and places, and as long as we realize that Art with a capital A has no existence.

2) The patience and skill which go into the faithful rendering of the visible world are indeed to be admired.

3) People who like pictures to look "real" are even more repelled by works which they consider to be incorrectly drawn, particularly when they belong to a more modern period.

4) We are all inclined to accept conventional forms or colors as the only correct ones. Otherwise, we dislike and criticize works of art.

5) Now, whatever we may think of modern artists, we may safely credit modern artists with enough knowledge to draw "correctly".

2. Translate the following sentences into English.

1) 《洛神赋图》(*Nymph of the Luo River*) 为东晋画家和诗人顾恺之所作的绢本长卷。这幅叙事画卷乃据曹植的《洛神赋》(*Ode to the Nymph of the Luo River*) 而作。

2) 这幅古画为长卷，需横览，它描绘了诗人曹植与洛神自邂逅定情到分别的爱情故事。

3) 这次比赛也打破了一直以来人们觉得科学家不懂艺术，艺术家不懂科学的成见。

4) 中国古代画家们在人物画中运用高超的技艺和丰富的想象，描绘出社会各阶层人物的物质与精神生活。

5) 木版年画（block-printed Chinese New Year pictures）是一种用于庆祝中国农历新年的民间艺术形式。

Writing Skills

Writing a Line Graph Essay

Part I — Preparation

Task 1 Introduction

A line graph is a graphical display of information that changes continuously over time. Within a line graph, there are various data points connected together by a line that reveals a continuous change in the values represented by the data points. It is also called a line chart. The line graph comprises of two axes known as "x" axis (horizontal) and "y" axis (vertical). Each axis represents a different data type, and the points at which they intersect is (0,0). The x-axis is the independent axis because its values are not dependent on anything measured. The y-axis is the dependent axis because its values depend on the x-axis' values. Line graphs can also be used as a tool for comparison: to compare changes over the same period of time for more than one group.

Task 2 Preparation Task

Fill in the blanks with appropriate words given in the box.

> interpret description paraphrase identify essential

1) It is _____ that you spend time on Step 1 "Analyze the question" and Step 2 "Identify the main features" as they are the key to writing a high-scoring line graph essay.

2) A line graph essay normally begins with a brief _____ of the topic covered by the graphic.

3) After you write the introduction of the line graph, you are expected to _____ the information by selecting and reporting the main features, and make comparisons where relevant.

4) To _____ the main feature, asking some useful questions will do, such as "What information do the two axes give?" "What main features stand out in this graphic?".

5) Then, you are ready to begin writing a line graph essay. In the first part "Introduction", you can _____ the title of the line graph to state what the graph is about.

Part II Reading Examples

Example 1

The graph shows average annual expenditures on cell phone and residential phone services between 2001 and 2010.

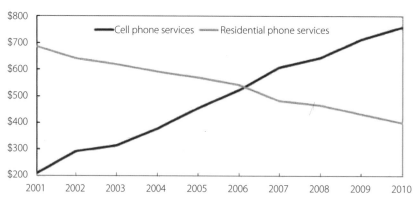

Chart 1. Average annual expenditures on cell phone and residential phone services, 2001–2010

SOURCE: U.S. Bureau of Labor Statistics, Consumer Expenditure Survey

The line graph illustrates the average cost that American customers spent on mobile and landline phone services annually over a 10-year period.

Overall, spending on residential phone services dramatically declined, while popularity of mobile services increased sharply throughout a decade. Also, both of services met at the same record in 2006.

In 2001, spending on mobile phone services began by merely $200, while the

amount of annual expenditure on the residential phone services was around $700. Over the following five years, expenditure on landline phone services gradually dropped below $600, whereas expenditure on cell phone services rose to just over $500.

In 2006 cell phones overtook landline phones, and the services became equal in popularity with customers' annual expenditure of about $550. Then, cell phone expenses rose to approximately $750 in 2010, making nearly a fourfold jump relatively to its initial figure in 2001. Meanwhile, spending on residential phone services experienced a steep fall in 2007 and went on to steadily decrease for the rest of the period.

Example 2

The graph below gives information from a 2008 report about consumption of energy in the USA since 1980 with projections until 2030.

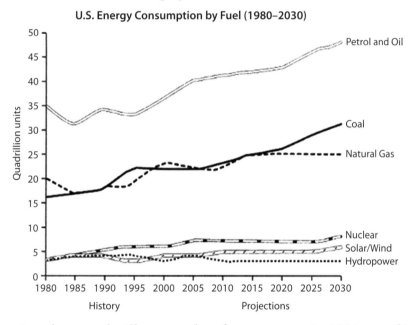

The given line graphs illustrates data from a report in 2008 regarding energy consumption in the USA since 1980 with predictions until 2030.

Overall, fossil fuels have shown increases in consumption since the start of the period, with expectations for even more reliance on these fuel sources. Cleaner energy sources have accounted for considerably less consumption with predictions for a similar trend.

Regarding fossil fuels such as coal, natural gas, petrol, and oil, they have seen steady increases in energy consumption since 1980. Petrol and oil started at 35 quadrillion units

in 1980, then fluctuated until 2000, at which point they rose steadily with a prediction of over 45 quadrillion units by 2030. Additionally, coal followed a similar rising trend. It is predicted that it will have surpassed 30 quadrillion units by 2030. As for natural gas usage, it is set to level off at around 24 quadrillion units from 2020 onwards.

In contrast, cleaner energy fuel sources all began the period at under 5 quadrillion units and showed declines in their use, with the exception of nuclear, which climbed slightly to 6 quadrillion units in 2005 with solar/wind expecting to see slight increases. Hydropower is projected to remain relatively unchanged until 2030.

Tips

- In the first paragraph, you should write about the topic of the line graph.
- The second paragraph is the overview of the line graph in which you should report the main features in a general manner.
- In the third and fourth paragraphs, you should include some detailed information about the data in the graphic.

Part III Task

The graph below shows how people buy music. Summarize the information by selecting and reporting the main features, and make comparisons where relevant. Write at least 150 words. (Please note: This graph was designed for writing practice only. The information in the graph may not be accurate.)

Percentage of total music sales by method

Learning Objectives

Students will be able to:

- know about the life and works of some visual artists;
- understand the meaning and value of art;
- grasp some vocabulary of fine arts;
- describe a chart in writing.

Unit **2**

Visual

Artists

Lead-In

Task 1 **Exploring the Theme**

Listen to a passage and choose the best answer.

1) Which of the following best summarizes the passage?

 A. The history of Chinese painting.

 B. The contradiction between *shen* and *xing* and how Qi Baishi realized the coexistence of the two.

 C. The relationship between likeness and unlikeness.

 D. The relationship between *shen* and *xing* and the unique contribution made by Qi Baishi.

2) According to the passage, what does *shen* refer to?

 A. The shape, color and any visual element of an artwork.

 B. The spirit.

 C. The emphasis placed on a particular area or characteristic of an artwork.

 D. A tactile quality of an object's surface.

3) What does *xing* refer to?

 A. The shape, color, and any visual element of an artwork.

 B. The spirit.

 C. The emphasis placed on a particular area or characteristic of an artwork.

 D. A tactile quality of an object's surface.

4) Here are four pairs of pictures. Which of them can be used to illustrate what is introduced in the passage?

 A.

B.

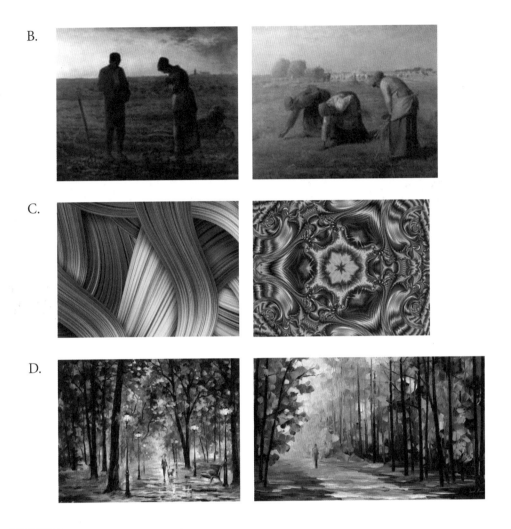

C.

D.

Task 2 Brainstorming

Discuss with your partner and answer the following questions.

1) How much do you know about Qi Baishi?

2) Have you ever viewed the paintings by Qi Baishi? What's your impression of them?

Task 3 Building Vocabulary

Discuss with your partners, and try to describe the following words in English.

scope specialty flamboyance brushwork literati

Reading A

Qi Baishi: The People's Artist

1 Qi Baishi (1864–1957), a native of Xiangtan, Hunan Province, was a painter who had enjoyed a long life. He was born to a poor family and once worked as a cowherd. At the age of twelve, he became a carpenter's **apprentice** and shortly afterwards, learned wood carving in an artistic fashion. Beginning at the age of twenty-six, as he worked as a carpenter in many famous men's houses, he came to know some painters who accepted him as their student. From then on, he devoted himself to painting and also to the writing of poetry. He and his friends even organized an association of poets known as Longshan, of which he was elected president.

apprentice *n.* 学徒；徒弟

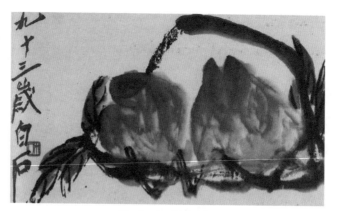

Peaches by Qi Baishi

2 Beginning at the age of forty, he visited many famous cities in China, including Xi'an, Beijing, Nanchang, Guilin, Guangzhou, Shanghai, Nanjing, and Chengdu, thus broadening his **intellectual** horizon and making more friends. Beginning at the age of sixty, he settled down in Beijing where he made a living by painting and **epigraphic** work. His works were appreciated by **renowned** artists like Chen Hengke[1] and Xu Beihong[2] who brought them to Japan and Western Europe where they were received with enthusiasm in exhibitions. He continued to be active after 1949, singing praises to the era. In 1953, he was awarded the honor as "The People's Artist". The year before his death, he received the International Peace Prize.

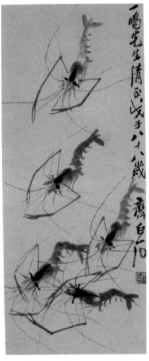

Shrimps by Qi Baishi

intellectual *adj.* 智力的；脑力的

epigraphic *adj.* 篆刻的

renowned *adj.* 有名的

3 The **subject matters** in Qi's paintings are wide in **scope**, including flowers and fruits, insects and birds, landscape, and human figures. But his **specialties** are flowers and plants, and grass and insects. Not only did he study and master the skills of such men as Xu Wei, Zhu Da, Yuan Ji, and Wu Changshuo, but he also most **penetratingly** observed and studied what he loved to draw. Outwardly he seemed to be very casual, but the flowers and

subject matter 题材

scope *n.* 范围

specialty *n.* 专长

penetratingly *adv.* 深刻地；尖锐地

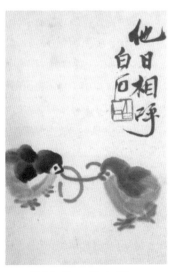

Chicks Share Tasty Worm
by Qi Baishi

1 陈衡恪 (1876–1923)，字师曾，中国画家、篆刻家。
2 徐悲鸿 (1895–1953)，中国画家、美术教育家。

plants that came out from his brush all possessed the kind of characteristics they should have. How **radiant** the red flowers looked! How refreshingly smooth the black leaves were!

radiant *adj.* 灿烂的；光芒四射的

4　In his drawing of such small animals as crabs, frogs, and shrimps, the lines are few, but the crabs seem to **crawl** energetically, the frogs swim swiftly, and the shrimps feel their way sensitively. In short, the pictured animals look simplistic but very much alive. The artist has created a world full of life and **rhythm**. He is skillful not only in blending "color" with "black" but also in combining "**flamboyance**" with "**delicacy**". His use of color is **audacious** as that normally found in New Year posters. His style is as honest and solid as that of Zhao Zhiqian[1], and his **brushwork** is as unpredictable as that of Wu Changshuo[2]. Meanwhile, he has been also successful in combining popular enthusiasm with the romantic and emotional brushwork that characterized the painters of the **literati**.

crawl *v.* 爬；爬行

rhythm *n.* 节奏；韵律

flamboyance *n.* 华丽；炫耀

delicacy *n.* 微妙；娇弱

audacious *adj.* 大胆的；敢于冒险的

brushwork *n.* （画家的）笔触；画法

literati *n.* 文人；文人学士

5　Most of his landscapes have in them only a few subject matters, but they convey to the viewer a unique sense of refreshment. He may, for instance, draw a few peach trees nearby and several water buffaloes in the

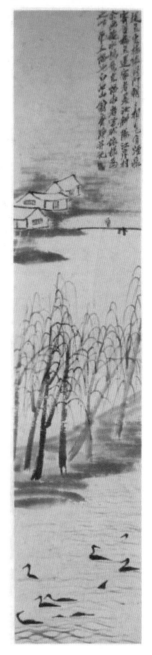

Poetic Landscape
by Qi Baishi

1　赵之谦 (1829–1884)，书画家、篆刻家。
2　吴昌硕 (1844–1927)，书画家、篆刻家。

distance. He may, on another occasion, draw a swarm of **herons** on a beach, while a few willows are dancing against the sunset on an autumn afternoon. All this cannot but help create a **poetic** atmosphere. It reminds one of a long-lost childhood or loneliness in a remote place when travelling alone. A simple article like a **hoe** or **abacus**, or a toy which always rights itself, begins to have a life of its own whenever it becomes a subject matter of his drawing. His brushwork is solid and powerful, and he often adds notes on his paintings to express his thoughts more fully or to serve as a **satire** against current events. He raises to a higher **plateau** the impressionist painting of flowers and birds and, in the process, also **ushers** our thoughts and feelings into a newer **realm**.

6 Qi Baishi gave himself a number of **sobriquets** that represented certain **episodes** in his life, his feelings, or his **outlook** on life. He was known as Baishi Shanren[1] (White Stone Mountain Man) or Baishi[2] (White Stone); when he called himself the "Woodman"[3], he was referring to the job he once had as a carpenter; when calling himself "**Reposing** in **Duckweed**", he was describing himself as being far away from home and loafing around like the duckweed floating in the water and driven by the wind. The sobriquet Sanbai Shiyin Fuweng[4] meant that he was the owner of three hundred stone seals and was considered a wealthy person both spiritually and morally. With the name Xingziwu Laomin[5], he described himself as an old farmer living in his native village, Xingziwu (Sunken Apricot Flowerbed). In middle age, Qi Baishi was still living in a rented house in the mountain, so he gave himself the surname Jieshanweng[6] (Old Man Borrowing the

heron *n.* 鹭；苍鹭

poetic *adj.* 富有诗意的；诗歌的

hoe *n.* 锄头

abacus *n.* 算盘

satire *n.* 讽刺作品；讽刺

plateau *n.* （发展、增长后的）稳定期；高原

usher *v.* 把……引往

realm *n.* 领域

sobriquet *n.* 外号；绰号

episode *n.* 片段；（人生的）一段经历

outlook *n.* 人生观

repose *v.* 位于；躺

duckweed *n.* 浮萍

1 白石山人。

2 白石。

3 木人。

4 三百石印富翁。

5 杏子坞老民。

6 借山翁。

Mountain).

(810 words)

(Adapted from: [1] Zhang A. *A History of Chinese Painting*. Beijing: Foreign Languages Press, 1992. [2] Barnhart R. M. *Three Thousand Years of Chinese Painting*. Beijing: Foreign Languages Press, 1997.)

Part I — Understanding the Text

Task 1 Global Understanding

1. Read the text and identify the main ideas.

1) What is the early life of Qi Baishi like? How does his early life help him start the lifelong career as a painter?

2) What are the distinct features of the artworks by Qi Baishi?

2. Read the text and decide whether the following statements are true (T) or false (F).

() 1) Since the age of twelve, Qi Baishi has made up his mind to become a painter.

() 2) The subject matters in Qi's artworks cover a wide range.

() 3) The painter's visits to different cities in China broaden his intellectual horizon and help him make more friends.

() 4) The animals in Qi's paintings look simple but are highly vivid.

() 5) The assumed names Qi Baishi gives to himself have little to do with his real-life experiences.

Task 2 Detailed Understanding

1. Read the text again and choose the best answer to each question below.

1) Which of the following statements is NOT true according to the passage?

A. Qi Baishi's early life is not smooth.

B. Qi Baishi's footprints cover many places in China.

C. Qi Baishi reproduces the subject matters in a highly sophisticated way.

D. Qi Baishi's brushwork is powerful.

2) According to the passage, the artist could "create a poetic atmosphere" with his landscape paintings. About this description, which of the following is true?

A. He creates the "poetic atmosphere" by faithfully representing details of the scenery.

B. He creates the "poetic atmosphere" with wild imagination.

C. His work reminds people of their own past experiences or the mood of a certain period.

D. His work creates an atmosphere that only exists in dreams.

3) In introducing Qi Baishi's artistic style, which of the following is NOT mentioned by the author?

A. His brushwork is conventional.

B. The lines are few, but the animals seem to move vividly.

C. The artist is skillful in blending "color" with "black".

D. The artist's use of color is audacious.

2. Answer the following questions according to the text.

1) Could you list the subject matters in Qi's paintings?

2) In Paragraph 4, the author describes Qi Baishi in this way: "He is skillful not only in blending 'color' with 'black' but also in combining 'flamboyance' with 'delicacy'." What's your understanding of this sentence?

3) According to the details introduced about the artist throughout the passage, could you summarize what kind of person he was?

Part II Building Language

Task 1 Key Terms

The following words or phrases are related to painting. Discuss with your classmates and provide your understanding about each term in English.

1) subject matter: _____

2) specialty: _____

3) line: _____

4) color: _____

5) brushwork: _____

6) literati painting: _____

Task 2 Vocabulary

Choose the correct word or phrase from the box below to complete each of the following sentences. Change the form where necessary.

renowned	subject matter	scope	specialty	penetratingly
radiant	rhythm	delicacy	audacious	landscape
poetic	plateau	usher	realm	outlook

1) I strongly recommend Caneo Restaurant. It is _____ as one of the region's best restaurants.

2) The illness had a profound effect on his _____ on life. After his recovery, he seemed to become much more optimistic.

3) Back by then, people's attitudes changed and artists were given greater freedom in their choice of _____.

4) In the end, they chose the candidate who had worked in the _____ of music education for three years.

5) The company's business _____ was wide, from design service to product manufacturing.

6) The second interviewee introduced his educational background and told us that his _____ was international banking.

7) Dear audience, the bell will soon toll to _____ in the new year!

8) After the crisis, the economy seemed to be stuck on a(n) _____ of slow growth.

9) With his _____ attitude to life, Li Bai created many literary works of immortality.

10) The moment I arrived, the beauty of the _____ overwhelmed me.

11) This series of products are noticeable with the _____ design: the colors are bold and the pattern is rarely used before.

12) In this novel, the author describes the harsh reality _____, offering the readers a deep insight into human nature.

13) The teacher taught us how to dance to the _____ of the music.

14) Sitting by the fire, her face was so _____ and her eyes sparkled wide with delight.

15) He held the glassware close to his eyes, appreciating the _____ of it.

Part III Translation

1. Translate the following sentences into Chinese.

1) His works were appreciated by renowned artists like Chen Hengke and Xu Beihong who brought them to Japan and Western Europe where they were received with enthusiasm in exhibitions.

2) The subject matters in Qi's paintings are wide in scope, including flowers and fruits, insects and birds, landscape, and human figures.

3) In his drawing of such small animals as crabs, frogs, and shrimps, the lines are few, but the crabs seem to crawl energetically, the frogs swim swiftly, and the shrimps feel their way sensitively.

4) He raises to a higher plateau the impressionist painting of flowers and birds and, in the process, also ushers our thoughts and feelings into a newer realm.

5) Qi Baishi gave himself a number of sobriquets that represented certain episodes in his life, his feelings, or his outlook on life.

2. Translate the following sentences into English.

1) 齐白石创作的岭南佳果系列寄托了画家对生活最朴素的祈愿，承载着他对岭南的喜爱之情。

2) 中年时的远游经历于艺术画匠齐白石而言至关重要，不仅丰富了他从艺初期的经历，而且对其后来的艺术提升和交流也起到一定的作用。

3) 齐白石的这一画作名为《山水十二条屏》，创作于 1925 年，每幅条屏都以优雅的配色展现出一片栩栩如生的自然风光。

4) 中国的文房四宝指的是笔、墨、纸、砚。它们在中国历史上扮演了重要的角色。

5) 五代十国到北宋时期被认为是中国山水画的全盛时期。

Reading B

Art Can Help

1 It is the responsibility of artists to pay attention to the world and to help us live respectfully in it. Artists do this by keeping their curiosity and moral sense alive, and by sharing with us their gift for metaphor. Often this means finding similarities between observable fact and inner experience.

distinguish *v.* 区分

gratitude *n.* 感激

2 More than anything else, beauty is what **distinguishes** art. Beauty is never less than a mystery, but it has within it a promise. In this way, art encourages us to **gratitude** and engagement, and is of both personal and civic consequence.

3 The subject of a painting or photograph does not by itself make it art, but if there is no important subject matter at all—no clarifying reference out to significant life beyond the frame— then the term increasingly seems to me **unearned**.

unearned *adj.* 不相称的

representation *n.* 表现；再现

4 Until fairly recently the word art as applied to pictures usually referred not just to **representations** of the world but to representations that suggested an importance greater than we might otherwise have assumed. Such pictures were said to

instruct and delight, which they did by their wholeness and richness. The effect was to reinforce a sense of meaning in life, though not necessarily a belief in a particular ideology or religion, and in this they were a binding cultural achievement.

bind *v.* 使有归属感；使团结在一起

5 Unfortunately art of this quality is now little attempted, partly because of disillusionment from a century of war, partly because of sometimes misplaced faith in the communicative and staying powers of total abstraction, and partly because of the ease with which lesser work can be made and sold. This atrophying away of the genuine article is a misfortune because, in an age of nuclear weapons and overpopulation and global warming, we need more than ever what art used to provide. Somehow, we have to recommit to picture making that is serious. It is impermissible any longer to endorse imitations that distract us or ridicule hope. The emptiness of material by Jeff Koons[1] and Damien Hirst[2], for example, is born of cynicism and predictive of nihilism.

disillusionment *n.* 幻灭；醒悟

atrophy *v.* 萎缩；衰退

impermissible *adj.* 不允许的；不许可的

endorse *v.* （公开）赞同；支持；宣传；代言

ridicule *v.* 嘲笑；奚落

cynicism *n.* 愤世嫉俗；冷嘲热讽

nihilism *n.* 虚无主义

6 Edward Hopper[3] was, it seems to me, the American painter who most deeply engaged with both what is modern and what is timeless. I'll try to identify a little of his achievement, and then to consider how the photographer Weifenbach[4] has also met the test of relevance.

Hopper's Paintings

7 What do we carry forward? My family lived in New Jersey near Manhattan until I was ten. When we left New Jersey for Wisconsin in 1947 I was homesick. The

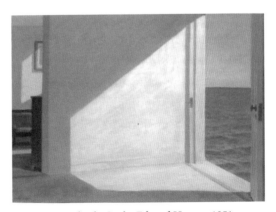

Rooms by the Sea by Edward Hopper, 1951

1 杰夫·昆斯（1955– ），美国当代波普艺术家。

2 达明安·赫斯特（1965– ），英国当代艺术家。

3 爱德华·霍珀（1882–1967），美国重要现实主义画家。

4 特里·魏芬巴赫（Terri Weifenbach, 1955– ），美国摄影艺术家。

palliative *n.* 缓解

only **palliative** I recall, beyond my parents' sympathy, was the accidental discovery in a magazine of pictures by a person of whom I had never heard but of scenes I recognized. The artist was Edward Hopper and one of the pictures was of a woman sitting in a sunny window in Brooklyn, a scene like that in the apartment belonging to a woman who had cared for my sister and me. Other views **resembled** those I recalled from the train to Hoboken. There was also a picture inside a second-floor restaurant, one strikingly like the restaurant where my mother and I occasionally had lunch in New York.

resemble *v.* 类似；像

8 The pictures were a comfort but of course none could permanently transport me home. In the months that followed, however, they began to give me something lasting, a realization of the **poignancy** of light. With it, all places were interesting.

poignancy *n.* 强烈；辛酸

9 Years later, when I found the other half of Hopper's work, the more rural half, that too was enabling. As a college student I tried to determine how much a person needed to adopt an ironic manner, and Hopper's paintings on Cape Cod and elsewhere in New England demonstrated that it was possible, without **sentimentality**, to express affection for places that were naturally beautiful. One did not need to be ashamed of having a heart.

sentimentality *n.* 多愁善感

10 Hopper's pictures still teach and please me in ways that seem new. As my memory of my youth fades some, for example, I think I do a little better when **conversing** with the young if I recall the painting of the usher there at the side of the movie theater, an individual partway between dream and experience. And when I look to my own future, I am grateful for Hopper's **transcriptions** of "sun in an empty room".

converse *v.* 交谈；谈话

transcription *n.* 转录；抄写；描绘

Weifenbach's Photos

11 Making a convincing photograph of a beautiful place is as hard as writing a convincing story about good people. We want to believe, but a lot of evidence stands in the way.

affirmation *n.* 肯定；维护

12 The **affirmations** that we credit are often those that we can check. We accept as plausible the flowers in Terri Weifenbach's

pictures, for instance, because they are the same ones that grow in our gardens.

13 And with that confirmed, we can be rescued. All winter we have stared at the backyard, and have ended nearly **hypnotized** by brown. How could we have missed the peony shoots?

hypnotize *v.* 使着迷；对……施催眠术

14 Weifenbach's photographs **reacquaint** us with nature's generosity: cosmos, sunflowers—varieties that hardly need cultivation. In the absence of wilderness, we rediscover by them how much is still a gift. Our dreams are of harmony. George Herbert[1], the seventeenth century English Poet, described one such vision:

reacquaint *v.* （使）重新了解；（使）再熟悉

15 Sweet day, so cool, so calm, so bright,

16 The bridal of the earth and sky.

17 If the lines now seem **antique** it is not because we think beautiful days unbelievable, but because we hesitate about the metaphor. And so, the manner of the pictures—taken at close distances and from extreme perspectives—is searching.

antique *adj.* 古老的

18 What does the photographer help us find? First of all, astonishment. Look at the picture of the bee, as **aeronautically** improbable as an angel.

aeronautically *adv.* 飞行地；航空地

(940 words)

(Adapted from: Robert A. *Art Can Help*. New Haven: Yale University Press, 2017.)

Terri Weifenbach, *XXV*, 25 March 1995, and *II*, 21 April 1996

1 乔治·赫伯特（1593—1633），英国诗人。

Part I Understanding the Text

Task 1 Global Understanding

1. Read the text and identify the main ideas.

1) How do you understand the title "Art Can Help"?

2) Talk with your classmates and discuss the emotion the author conveyed through the passage.

2. Write down the key idea of each paragraph below.

Paragraph 1: _____

Paragraph 7: _____

Paragraph 9: _____

Task 2 Detailed Understanding

1. Answer the following questions according to the text.

1) According to the author, why are pictures aimed to "instruct and delight" now "little attempted"?

2) Why does the author mention Edward Hopper?

3) What do Edward Hopper and Weifenbach have in common?

2. Discuss the following questions with your partner.

1) How do you understand "finding similarities between observable fact and inner experience" in Paragraph 1?

2) What does the author think of the "atrophying away of the genuine article" in Paragraph 5?

3) Why does the author mention his own childhood experience in Paragraph 7?

Part II Building Language

Task 1 **Key Terms**

The following words are related to fine arts. Discuss with your classmates and provide your understanding about each term in English.

1) represent: _____

2) representation: _____

3) representational: _____

4) nonrepresentational: _____

5) aesthetics: _____

6) resemble: _____

Choose the correct word from the box below to complete each of the following sentences. Change the form where necessary.

distinguish	gratitude	representation	binding	ridicule
cynicism	resemble	sentimentality	affirmation	hypnotize
reacquaint	nihilism	palliative	impermissible	antique

1) The twin sisters look alike. It is so hard to _____ one from the other.

2) He travelled there by boat and at a local farmer's cottage he discovered a(n) _____ vase.

3) If you move back to Boston after several years in Tokyo, you might have to _____ yourself with the subway system.

4) _____ comes from believing that people are, at heart, selfish and untrustworthy.

5) She was presented with the gift in _____ for her long service.

6) The painting is a(n)_____ of the vast cosmos in the eyes of the artist.

7) She _____ her mother very much. From the eyes, the nose and the lips, one can tell their relationship instantly.

8) When you _____ someone, you draw him into a mental state that is receptive to suggestion.

9) _____ care means to provide care to patients which can help alleviate symptoms without curing the underlying disease.

10) With the movie, the director seems to be trying to tap into a general _____ about animals.

11) _____ refers to the doctrine that nothing can be known.

12) A(n) _____ is a big fat yes (俚语，非常肯定), an assertion that something is true.

13) The treaty and agreement are both _____ and of equal importance.

14) His older sibling constantly _____ him with sarcastic remarks.

15) Terrorism is outrageous and _____. It causes nothing but strong indignation.

Part III Translation

1. Translate the following sentences into Chinese.

1) Often this means finding similarities between observable fact and inner experience.

2) More than anything else, beauty is what distinguishes art. Beauty is never less than a mystery, but it has within it a promise.

3) And when I look to my own future, I am grateful for Hopper's "sun in an empty room".

4) Weifenbach's photographs reacquaint us with nature's generosity: cosmos, sunflowers—varieties that hardly need cultivation.

5) If the lines now seem antique it is not because we think beautiful days unbelievable, but because we hesitate about the metaphor.

2. Translate the following sentences into English.

1) 艺术创作的动机之一，就是铭刻重要却易逝的经历，保存短暂而美好的回忆。

2) 即使当人们所爱之物逝去之时，艺术也能以片段的方式留住美好。

3) 优美而令人愉悦的艺术作品通过呈现理想的世界让人们保持乐观的天性和对未来的希望。

4) 语言可以帮助我们表达情绪，而艺术却可以激发我们的情绪和共鸣。

5) 摄影更为深层次的意义是人们以摄影这种表现形式传达自己的思想和情绪。

Writing Skills

Describing a Chart

Part I Preparation

Task 1 **Introduction**

One important way to make our presentations more attractive to the listeners or to make our writing more vivid to the readers is to use charts, graphs, and diagrams. The visual content helps people see what we are talking about. Thus, to know how to describe them correctly is essential.

Task 2 **Preparation Task**

The following are the sentences we might use in describing a chart. Fill in the blanks with the right words given in the box. There might be more than one correct answer.

| compared increased steady fluctuated shrunk fell |

1) In 2002 the figures _____ from 25% to 30%.

2) Temperatures _____ in autumn.

3) The price of oil remained _____ during that period.

4) The cost of electricity _____ during those five years.

5) The number of the teaching staff at this school has _____ from 936 in 1991 to 625 in 2021.

6) _____ with that of last year, the output of 13 main products this year has increased significantly.

Part II Reading Example

Example

Percentage of Chinese men and women doing regular physical exercise in 2019

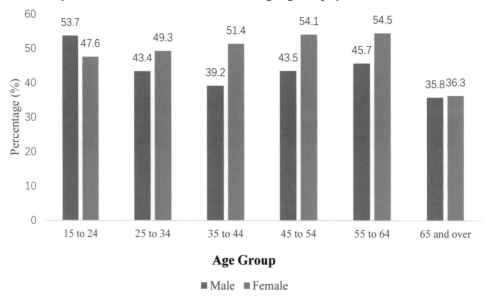

Age Group

■ Male ■ Female

The bar chart depicts the gender distribution of Chinese in different age groups who took part in regular physical exercise in the year 2019.

It is manifested from this bar chart that, in four of the six age groups, women had the obvious advantage in the percentage of participating in regular physical activities in 2019. To be specific, the dominance stood in the adulthood, from the age of 25 to 64. Their gaps ranged from 5.9% to 12.2% and generally we can see an increasing trend in both figures.

By comparison, the adolescence and younger people, namely from 15 to 24, was the only period when the male percentage exceeded that of female and the gap was about 6%. What should be noticed was that 53.7% was the men's highest figure in all groups.

As for the elderly people, men and women were more equally represented (35.8% and 36.3% respectively).

Overall, younger men preferred to participate in regular sporting activities compared with middle-aged women who had the greatest enthusiasm for exercise. In the age group of 35 to 64, both genders were increasingly willing to participate in sports activities, yet the willingness declined greatly after both genders reached the age of 65.

Tips

- Start by describing what you see in the chart; provide an overview of the key features of the information.
- Move on with describing the patterns or trends in a more detailed way. In this process, select the most important ones and don't write about your own ideas.
- Use linking words and a variety of vocabulary.
- Be careful with tenses.

Part III Task

Describe the following chart with at least 150 words.

% of Americans 16+ who have read both e-books and printed books in the last 12 months

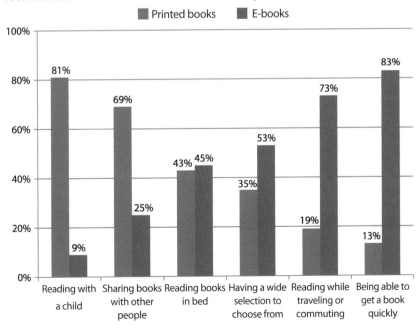

Students will be able to:

- understand the vocabulary of music composition;
- describe music pieces in music language;
- gain an appreciation of Western and Chinese music works;
- learn how to write about and compare two pie charts.

Unit 3

World Famous
Composers

Lead-In

Task 1 **Exploring the Theme**

Watch a short video clip and answer the questions.

1) What's the title of the opera in the video clip?

2) What's the musical device used by Wagner which was to become the single most structural and stylistic element in all his subsequent music?

Task 2 **Brainstorming**

Answer the following questions.

1) What are the essential elements of music language?

2) What Chinese traditional music pieces do you know?

Task 3 **Building Vocabulary**

Discuss with your classmates, and try to describe the following words and phrases in English.

music drama	orchestral unison	irrational impulse
dynamic	self-vulgarized	

Reading A

Richard Wagner[1]
—the Father of Music Drama

1 Wagner was a German composer, theatre director, and conductor who is chiefly known for his operas (or, as some of his mature works were later known, "**music dramas**"). Unlike most opera composers, Wagner wrote both the **libretto** and the music for each of his stage works. Wagner **innovated** opera through his concept of the "total work of art", by which he sought to **synthesize** the poetic, visual, musical and dramatic arts, with music **subsidiary** to drama. He described this vision in a series of essays published between 1849 and 1852. Wagner realized these ideas fully, in the first half of the four-opera cycle *The Ring of the Nibelung*[2].

music drama 音乐戏剧
libretto *n.* 剧本
innovate *v.* 创新

synthesize *v.* 合成
subsidiary *adj.* 附属的

2 His compositions, particularly those of his later period, are notable for their complex **textures**, rich **harmonies** and **orchestration**, and the **elaborate** use of **leitmotifs**—**musical phrases** associated with individual characters, places, ideas,

texture *n.* 织体；结构
harmony *n.* 和声
orchestration *n.* 配器
elaborate *adj.* 复杂的；详尽的；精心的
leitmotif *n.* 主导动机
music phrase 乐句

1 理查德·瓦格纳 (1813–1883)，出生于德国莱比锡，浪漫主义时期德国作曲家、指挥家。

2 《尼伯龙根的指环》，瓦格纳作曲及编剧的一部大型音乐戏剧，由四部歌剧组成。

chromaticism *n.* 半音体系

tonal center 调性中心

or plot elements. His advances in musical language, such as extreme **chromaticism** and quickly shifting **tonal centres**, greatly influenced the development of classical music. His *Tristan and Isolde*[1] is sometimes described as marking the start of modern music.

embody *v.* 体现

novel *adj.* 新颖的

premier *v.* 首演

descendant *n.* 后代

3　Wagner had his own opera house built, the Bayreuth Festspielhaus[2], which **embodied** many **novel** design features. *The Ring* and *Parsifal*[3] were **premiered** there and his most important stage works continue to be performed at the annual Bayreuth Festival[4], run by his **descendants**. His thoughts on the relative contributions of music and drama in opera were to change again, and he reintroduced some traditional forms into his last few stage works, including *The Mastersingers of Nuremberg*[5].

exile *n.* 流放

turbulent *adj.* 动荡的

creditor *n.* 债主

controversial *adj.* 有争议的

antisemitic *adj.* 反犹太人的

visual arts 视觉艺术

4　Until his final years, Wagner's life was characterized by political **exile**, **turbulent** love affairs, poverty and repeated flight from his **creditors**. His **controversial** writings on music, drama and politics have attracted extensive comment—particularly, since the late 20th century, where they express **antisemitic** sentiments. The effect of his ideas can be traced in many of the arts throughout the 20th century; his influence spread beyond composition into conducting, philosophy, literature, the **visual arts** and theatre.

Influence on music

key *n.* 调

chord *n.* 和弦

atonality *n.* 无调性

5　Wagner's later musical style introduced new ideas in harmony, melodic process (leitmotif) and operatic structure. Notably from *Tristan and Isolde* onwards, he explored the limits of the traditional tonal system, which gave **keys** and **chords** their identity, pointing the way to **atonality** in the 20th century.

1　《特里斯坦和伊索尔德》，瓦格纳歌剧。
2　德国拜罗伊特节日剧院，专门上演瓦格纳歌剧。
3　《帕西法尔》，瓦格纳音乐戏剧。
4　拜罗伊特音乐节，专门演出瓦格纳作品。
5　《纽伦堡的名歌手》，瓦格纳音乐戏剧。

Some music historians date the beginning of modern classical music to the first notes of *Tristan*, which include the so-called Tristan chord.

6 Wagner inspired great devotion. For a long period, many composers **were inclined to align** themselves **with** or against Wagner's music. Mahler[1] was devoted to Wagner and his music. Aged 15, he sought him out on his 1875 visit to Vienna[2], became a renowned Wagner conductor, and his compositions are seen by Richard Taruskin[3] as extending Wagner's "maximalization" of "the **temporal** and the **sonorous**" in music to the world of the **symphony**. The harmonic revolutions of Debussy[4] and Schoenberg[5] (both of whose works contain examples of tonal and atonal modernism) have often been traced back to *Tristan* and *Parsifal*. The Italian form of **operatic realism** known as **verismo owed** much **to** the Wagnerian concept of musical form.

be inclined to 倾向于
align...with 支持

temporal *adj.* 时间的
sonorous *adj.* 响亮的
symphony *n.* 交响乐

operatic realism　现实主义歌剧
verismo *n.* 写实主义
owe...to 归因于

7 Wagner made a major contribution to the principles and practice of conducting. His essay "About Conducting" (1869) advanced Berlioz's[6] technique of conducting and claimed that conducting was a means by which a musical work could be re-interpreted, rather than simply a mechanism for achieving **orchestral unison**. He exemplified this approach in his own conducting, which was significantly more flexible than the disciplined approach of Mendelssohn; in his view this also **justified** practices that would today **be frowned upon**, such as the rewriting of scores.

orchestral unison 管弦乐一致

justify *v.* 证明……正确（或正当、有理）
be frowned upon 被诟病

1　马勒 (1860–1911)，奥地利作曲家、指挥家。
2　维也纳，奥地利首都，被誉为"世界音乐之都"。
3　理查德·塔鲁斯金，美国音乐学家，著有《牛津西方音乐史》。
4　德彪西 (1862–1918)，法国作曲家，音乐评论家，形成了"印象主义"音乐风格。
5　勋伯格 (1874–1951)，美籍奥地利作曲家、音乐教育家和音乐理论家，西方现代主义音乐的代表人物。
6　柏辽兹 (1803–1869)，法国作曲家，法国浪漫乐派的主要代表人物。

Tristan and Isolde

8 While composing the opera *Siegfried*[1], the third part of *The Ring* cycle, Wagner interrupted work on it and wrote the tragic love story *Tristan and Isolde*, an opera about two lovers whose passion for each other is so intense that it can only be **consummated** in death. The story is closely connected with the writings of Arthur Schopenhauer[2] with whose theories Wagner became **obsessed**. Schopenhauer argued that human behavior is governed not by the intellect, but by the **irrational impulses** of the human will which includes ambition, love, hate and desire. One possible release from this **torment** of life is death. Wagner, when he took on *Tristan and Isolde*, he wanted to write something really different. He thought of all he could do to make it more different and more striking. The opening phrase of *Tristan and Isolde* ends on a chord which leaves us all up in the air waiting for a **resolution** which doesn't come. Wagner gives a kind of **prominence** to a feeling of non-resolution which was unique in the history of harmonic language up till that time. In that way alone it stands out as one of the two or three major musical events of the whole 19th century.

9 *Tristan* is often granted a special place in musical history; many see it as the beginning of the move away from conventional harmony and tonality and consider that it **lays the groundwork for** the direction of classical music in the 20th century. Wagner felt that his musico-dramatical theories were most perfectly realised in this work with its use of "the art of **transition**" between dramatic elements and the balance achieved between vocal and orchestral lines.

(880 words)

(Adapted from wikipedia website.)

consummate *v.* 完成；成就

obsess *v.* 着迷

irrational impulse 非理性冲动

torment *n.* 折磨

resolution *n.* 终结

prominence *n.* 重要；突出

lay the groundwork for 为……奠定基础

transition *n.* 转化

1　《奇格弗里德》,《尼伯龙根的指环》中的第三联。
2　叔本华 (1788–1860)，德国著名哲学家，唯意志论的创始人。

Part I Understanding the Text

Task 1 Global Understanding

1. Read the text and identify the main idea.

1) What is Wagner's influence on opera and music?

2) Can you write down what innovative ideas are exemplified in Wagner's two masterpieces?

The Ring of the Nibelung: _____

Tristan and Isolde: _____

2. Read the text and decide whether the following sentences are true (T) or false (F).

() 1) Like most opera composers, Wagner only wrote the music for each of his stage works.

() 2) His *Tristan and Isolde* is sometimes described as marking the start of classical music.

() 3) Some music historians date the beginning of modern classical music to the first notes of Parsifal.

() 4) The Italian form of operatic realism known as verismo owed much to the Wagnerian concept of musical form.

() 5) Many see Tristan as the beginning of the move to conventional harmony and tonality.

Task 2　Detailed Understanding

1. Read the text again and choose the best answer to each question below.

1) Which of the following is NOT Wagner's work?

 A. *The Ring of the Nibelung.*　　　　B. *Tristan und Isolde.*

 C. *The Pastoral Symphony.*　　　　 D. *Parsifal.*

2) What does "verismo" in Paragraph 6 mean?

 A. Chromaticism.　　　　　　　　B. Operatic realism.

 C. Dramatism.　　　　　　　　　 D. Classicism.

3) Why does the author say "the opening phrase of *Tristan and Isolde* ends on a chord which leaves us all up in the air" in Paragraph 8?

 A. Because we are so excited to get lost in the music.

 B. Because we are too tired to focus on the music.

 C. Because we know exactly where the music is going.

 D. Because we are waiting for a resolution which doesn't come.

2. Answer the following questions according to the text.

1) What is the meaning of "with music subsidiary to drama" in Paragraph 1?

2) According to the text, what makes Wagner a controversial figure?

3) How do you understand the sentence in Paragraph 7, "his essay... 'claimed that conducting was a means by which a musical work could be re-interpreted, rather than simply a mechanism for achieving orchestral unison'"?

Part II Building Language

Task 1 Key Terms

The following words or phrases are related to music. Discuss with your classmates and provide your understanding about each term in English.

1) libretto: _____

2) key: _____

3) symphony: _____

4) leitmotif: _____

5) premier: _____

6) chord: _____

7) texture: _____

8) orchestration: _____

9) harmony: _____

10) tonal center: _____

11) music phrase: _____

12) verismo: _____

Task 2 Vocabulary

Choose the correct word or phrase from the box below to complete each of the following sentences. Change the form where necessary.

subsidiary	embody	elaborate	be associated with	be inclined to
align…with	owe…to	justify	be frowned upon	lay the groundwork for
synthesize	novel	premier	sonorous	consummate

1) She had prepared a(n) _____ excuse for her absence.

2) His reaction can _____ trauma and some illnesses.

3) Church leaders have _____ themselves _____ the opposition.

4) He _____ his success not _____ luck but ability.

5) None doubted his ability, but his friends _____ his frankness.

6) It's just that Elvis managed to _____ the frustrated teenage spirit of the 1950s.

7) Jack took advantage of this chance to _____ his career.

8) How can we _____ spending so much money on arms?

9) I'm taking history as a(n) _____ subject.

10) Some of us may just _____ gain weight while others are not, due to genetics.

11) The *pipa* is a(n) _____, four-stringed, pear-shaped instrument held upright on the lap.

12) Scientists have come up with a(n) _____ way of catching fish.

13) Rossini's work had its _____ at the Paris Opera.

14) The latter part of the wide-ranging agreement has not yet been _____.

15) All of this information is easy to obtain, but it's up to you to be discerning about how you _____ it.

Task 3 **Grammar and Structure**

Complete the following sentences by translating the Chinese given in brackets into English. You should use the word "as" which means "while" "because" "although" or "in the way", or is used to make a comment or add information about what you have just said.

1) _____ (随着年龄的增长) she gained in confidence.

2) She may need some help _____ (因为她是新来的).

3) _____ (尽管他们很快乐), there was something missing.

4) Leave the papers _____ (别动那些文件).

5) _____ (你是知道的), Julia is leaving soon.

6) They did _____ (按照我的要求).

7) She's very tall, _____ (和她母亲一样).

8) He sat watching her _____ (等她就绪).

9) _____ (因为你不在), I left a message.

10) _____ (他想尽了办法), he couldn't open the door.

Part III Translation

1. Translate the following sentences into Chinese.

1) Wagner innovated opera through his concept of the "total work of art", by which he sought to synthesize the poetic, visual, musical and dramatic arts, with music subsidiary to drama.

2) The effect of his ideas can be traced in many of the arts throughout the 20th century; his influence spread beyond composition into conducting, philosophy, literature, the visual arts and theatre.

3) Wagner's later musical style introduced new ideas in harmony, melodic process (leitmotif) and operatic structure.

4) His essay "About Conducting" advanced Berlioz's technique of conducting and claimed that conducting was a means by which a musical work could be re-interpreted, rather than simply a mechanism for achieving orchestral unison.

5) Wagner felt that his musico-dramatical theories were most perfectly realised in _Tristan_ with its use of "the art of transition" between dramatic elements and the balance achieved between vocal and orchestral lines.

2. Translate the following sentences into English.

1) 歌剧是一种脚本配上音乐、在舞台上表演的戏剧。

2) 瓦格纳与贝多芬都是著名作曲家，两人在音乐领域都取得了巨大成就。

3) 《尼伯龙根的指环》围绕着获得一枚金戒指展开。这枚戒指承诺，任何人拥有了它且自愿放弃爱情即可主宰世界。

4) 所有不同种类的歌剧都基于一个共同的理念：音乐——尤其是歌唱——能够强化戏剧效果。

5) 许多现代音乐家都认为，摆脱瓦格纳的巨大影响、形成自己的风格是 19 世纪之后古典音乐的主要奋斗目标。

Reading B

Ideal and Practice—Composer's Notes on the Symphonic Series
Rhapsody of China[1]

By Bao Yuankai[2]

Translated by Zhang Beili[3]

1 It was in 1990 when I began to re-study various Chinese folksongs, dance music, **ballad music**, traditional operas, and instrumental music. My plan was to compose **orchestral** works based on the best tunes selected from our musical tradition in order to make the colorful and charming Chinese folk or traditional music to be enjoyable for all people in the present world. I supposed that the new works should be both "**symphonic**" in form and "Chinese" **in essence** and, later, I realized the plan in about ten years with the **resultant** symphonic series *Rhapsody of China*.

2 To combine Chinese folk or traditional music with Western modern symphonic forms is a practical way to break up the

ballad music 民谣
orchestral *adj.* 管弦乐的

symphonic *adj.* 交响乐的
in essence 本质上
resultant *adj.* 由此引起的；因而发生的

1 交响乐《中国风》，鲍元恺创作的以西方音乐形式来展现中国传统音乐的交响乐系列，包括《炎黄风情》《台湾音画》《华夏弦韵》等七个篇章。
2 鲍元恺，作曲家、音乐教育家。
3 译者张蓓荔，天津音乐学院音乐学教授。

isolation of Chinese music and bring it up to the world's stage. Symphonic music is one of the most expressive and capable musical types developed by European musicians **in pace with** the Industrial Revolution. With the blending of different musical traditions, a large number of symphonic works, which reflect varied social life and **aesthetic** demands in varied styles, have been produced in the past by composers from countries outside Europe. Originated in religious music, European professional music is highly developed with strict **notation**, **systematized** harmony, **dynamic** part writing, and logical structure. Chinese traditional music, on the contrary, implies verve in the **facets** of simple events. The difference provides us a good opportunity to show our creativity.

in pace with 随着

aesthetic *adj.* 审美的

notation *n.* 记谱
systematized *adj.* 系统的
dynamic *adj.* 充满活力的；力度的
verve *n.* 活力；韵味
facet *n.* 方面
suite *n.* 组曲

3 In 1991, my orchestral **suite** *24 Orchestral Pieces on the Themes Selected from Chinese Folksongs*[1] was premiered in Tianjin. The work consists of six chapters[2], entitled *Stories on the Lands of Ancient Yan and Zhao*, *Sketches of the Highland of Yuannan*, *Sadness and Happiness on the Yellow Soil Highland*, *Mountain Songs of the Ancient States Ba and Shu*, *Drizzle in the South*, and *Seasons in Taihang Mountains*, each of which has four pieces composed on popular themes respectively selected from the Han folksongs in the provinces of Hebei, Yuannan, Shaanxi, Sichuan, Jiangsu, and Shanxi. In 1994, I renamed the suite as *Chinese Sights and Sounds*[3] to be the **initial** part of my enlarged plan *Rhapsody of China*. In 1995, I added the seventh chapter, *Charming Tunes of Taiwan*[4], to the suite. Since 2001, I have finished the series' following parts *Beijing Symphony*[5] in 1995, *Chinese Children's Songs*[6] in 1997, *Symphonic Sketches*

initial *adj.* 最初的

1 《中国民歌主题二十四首管弦乐曲》，鲍元恺创作的一部以西方交响音乐形式展现中国汉族民歌神韵的大型组曲。
2 《燕赵故事》《云岭素描》《黄土悲欢》《巴蜀山歌》《江南雨丝》《太行春秋》。
3 《炎黄风情》。
4 《台乡清韵》。
5 《京都风华》。
6 《华夏童谣》。

of Taiwan[1] in 1999, and *Melody of the Qin for Strings*[2] in 2001. Styles and techniques applied in this series are not necessarily unified; for developing the folksong themes I may use *basso ostinato*, **canon**, **fugue**, or any new techniques from the 20th-century.

basso ostinato 固定低音

canon *n.* 卡农曲

fugue *n.* 赋格

4 Having not been reformed by industrialization or **renaissance**, Chinese traditional music has kept its **prototype** of the agricultural society all along; this is indeed an advantage that could be taken by Chinese composers. In this sense, we have a rich and broad **virgin** soil. Therefore, early Chinese modern composers **attached great importance to** the discovery from Chinese folk music. As the founding figures of Chinese new music education, both Xiao Youmei[3] and Huang Zi[4] **advocated** using folk music as material to compose new music when they started their teaching in the 1920s and 1930s. Meanwhile, Jiang Wenye[5] in Japan composed *Taiwan Dance*[6] in 1934 and Ma Sicong[7] used Suiyuan folksong themes for his *Inner Mongolian Suite*[8] and *First Rondo Suiyuan*[9] for violin in 1937. In the early 1940s, Xian Xinghai[10] composed *Capriccio of China*[11] for orchestra in Russia based on five Chinese folksongs. In 1945, He Luting[12] composed an orchestral piece *Senji Dema*[13] on the theme of a Mongolian folksong. Late, Ma Ke[14] composed

renaissance *n.* 文艺复兴

prototype *n.* 雏形

virgin *adj.* 未开发的

attach great importance to 非常重视

advocate *v.* 提倡

1 《台湾音画》。

2 《华夏弦韵》。

3 萧友梅 (1884–1940)，作曲家、教育家、音乐理论家，被誉为"中国现代音乐之父"。

4 黄自 (1904–1938)，作曲家、音乐教育家，对中国早期音乐教育影响最大的奠基人之一。

5 江文也 (1910–1983)，中国台湾作曲家。

6 《台湾舞曲》。

7 马思聪 (1912–1987)，小提琴家、作曲家、音乐教育家。

8 《内蒙组曲》。

9 《第一回旋曲 (绥远)》。

10 冼星海 (1905–1945)，著名作曲家、钢琴家，被誉为"人民音乐家"。

11 《中国狂想曲》。

12 贺绿汀 (1903–1999)，著名音乐家、教育家。

13 《森吉德玛》。

14 马可 (1918–1976)，作曲家。

Shaanbei Suite[1] in 1949. All these experiences made significant efforts towards the establishment of Chinese symphonic music, which **flourished** in the 1950s and early 1960s with the representative works of the **symphonic suite** *Spring Festival*[2] by Li Huanzhi[3], the **symphonic poem** *Gada Meilin*[4] by Xin Huguang, and the Violin Concerto *Butterfly Lovers*[5] by He Zhanhao[6] and Chen Gang[7].

flourish *v.* 繁荣

symphonic suite 交响组曲

symphonic poem 交响诗

5 The history of using Western techniques in Chinese new music creation is not over a century. In this situation, we must consider the acceptability of our works to the common Chinese audience when we compose. We hope our music can be accepted by the world. But, if it is not acceptable even by Chinese people, the efforts towards the world would not come true. I then **proposed** that my *Rhapsody of China* should make Chinese know more about the Western music form through the music familiar to them and make the foreigners know more about the charming **connotation** of Chinese music with the form familiar to them. A Chinese proverb describes this principle as *ya su gong shang* ("to suit both **refined** and popular tastes")[8].

propose *v.* 提出；主张

connotation *n.* 内涵

refined *adj.* 高雅的

6 In my opinion, a classical work must be both refined and popular, no matter it is Western or Eastern, ancient or modern. Chinese symphonic **repertoires** are all works with this feature. Today, when we review the principle, what we want to do is to build up a way, which is neither **self-admired** nor **self-vulgarized**, to continue the tradition under the market-economy society and refine-popular split cultural background. I am not interested in showing my distinct personal style in my

repertoire *n.* 曲目

self-admired *adj.* 自我夸赞的

self-vulgarized *adj.* 自我贬低的

1 《陕北组曲》。

2 《春节》。

3 李焕之 (1919–2000)，作曲家、指挥家、音乐理论家。

4 《嘎达梅林》。

5 《梁祝》。

6 何占豪 (1933–)，作曲家，创作了中国第一部小提琴协奏曲《梁祝》。

7 陈钢 (1935–)，作曲家，创作了中国第一部小提琴协奏曲《梁祝》。

8 雅俗共赏。

composition. On the contrary, what I am devotedly pursuing is to express the true feelings of common people. I believe that the aesthetic value of both folk music and professional music is eventually determined by the depth and broadness of the music's expression of human being's spirits but nothing else.

(901 words)

(From: Bao Y. Translated by Zhang B. *Music in China*, 2002(4): 187–196.)

Part I Understanding the Text

Task 1 Global Understanding

1. Read the text and identify the main idea. Answer the following questions.

1) What's the writer's plan to make the colorful and charming Chinese folk or traditional music to be popular with people all over the world?

2) How do you understand the principle "*ya su gong shang*" ("to suit both refined and popular tastes") in music composition?

2. Work out the appropriate headings for the paragraphs below.

Paragraph 1: _____

Paragraph 2: _____

Paragraph 5: _____

Paragraph 6: _____

Task 2 Detailed Understanding

1. Answer the following questions according to the text.

1) What are the old Western techniques the composer used in his composition?

2) Who are the founding figures of Chinese new music education?

3) Who are the two composers collaborating to compose the famous Chinese Violin Concerto *Butterfly Lovers*?

2. Discuss the following questions with your partner.

1) What does the writer mean by saying his "new works should be both 'symphonic' in form and 'Chinese' in essence"?

2) What are the characteristics of Western modern symphonic music?

3) What advantages can Chinese composers gain from Chinese traditional music?

Part II Building Language

Task 1 Key Terms

The following words or phrases are related to music. Discuss with your classmates and provide your understanding about each term in English.

1) symphonic: _____

2) basso ostinato: _____

3) fugue: _____

4) orchestral: _____

5) suite: _____

6) repertoire: _____

7) canon: _____

8) symphonic poem: _____

9) ballad music: _____

10) notation: _____

Vocabulary

Match the synonyms on the right with the words on the left.

1) verve A elegant

2) refined B model

3) facet C energy

4) prototype D meaning

5) aesthetic E suggest

6) flourish F aspect

7) advocate G thrive

8) propose H first

9) connotation I support

10) initial J esthetic

11) systematized K energetic

12) virgin L self-depreciate

13) dynamic M original

14) self-admire N systematic

15) self-vulgarize O self-praise

Task 3 **Grammar and Structure**

The suffix "-al" combines with nouns to form adjectives. Write the adjective form of each noun and then complete the following sentences by translating the Chinese given in brackets into English.

instrument — *instrumental*

orchestra — essence —

logic — culture —

music — person —

spirit — tradition —

agriculture —

1) Ragtime remains distinct from jazz both as a genre and _____ （作为一种器乐风格）.

2) The *Butterfly Lovers'* Violin Concerto is _____ （器乐改编自中国的传统故事）, the *Butterfly Lovers*.

3) Money is _____ （对于幸福并非必不可少）.

4) Computer programming needs _____ （擅长逻辑思维的人）.

5) The orchestra is _____ （对这座城市的文化生活而言非常重要）.

6) People's opinions differ about what music is and _____ （什么是悦耳的音乐）.

7) I try not to let work _____ （干扰我的私人生活）.

8) Literature can _____ （丰富你的精神生活）.

9) _____ （传统的教学方法） sometimes put students off learning.

10) Rivers are a blessing _____ （对于农业国来说）.

Part III Translation

1. Translate the following sentences into Chinese.

1) My plan was to compose orchestral works based on the best tunes selected from our musical tradition in order to make the colorful and charming Chinese folk or traditional music to be enjoyable for all people in the present world.

2) To combine Chinese folk or traditional music with Western modern symphonic forms is a practical way to break up the isolation of Chinese music and bring it up to the world's stage.

3) Having not been reformed by industrialization or renaissance, Chinese traditional music has kept its prototype of the agricultural society all along; this is indeed an advantage that could be taken by Chinese composers.

4) My *Rhapsody of China* should make Chinese know more about the Western music form through the music familiar to them and make the foreigners know more about the charming connotation of Chinese music with the form familiar to them.

5) I believe that the aesthetic value of both folk music and professional music is eventually determined by the depth and broadness of the music's expression of human being's spirits but nothing else.

2. Translate the following sentences into English.

1) 中国文明是世界上最为古老的文明之一，其音乐体系与乐器的发展历史远早于大多数其他各国。

2) 从古至今，描述性的音乐在中国总是很流行。

3) 所有的语言都有音乐的成分，因为人在发音时会有自然的升降，而词语也会呈现出节奏特征。

4) 中国音乐的记谱也使用汉字书写，这些汉字既表示音符名称也表示音高。

5) 中国传统作曲家经常用不同的调性体系创作，这和西方的古典音乐不同。

Writing Skills

Describing and Comparing Two Pie Charts

Part I Preparation

Task 1 Introduction

A pie chart is a circular chart divided into sectors, illustrating numerical proportion. You'll learn how to compare pie charts with each other to get the information you need and to assess the situation shown in each pie chart. This is a useful skill as you'll encounter various graphs, including pie charts, in the real world that show you important information you need to make important decisions.

Task 2 Preparation Task

Fill in the blanks with the appropriate words given in the box.

> contrast while however instead similarly as well

1) Both tablet usage and smartphone usage are growing. _____, they are used in very different ways.

2) Fewer people watch television in the evenings now. _____, for entertainment, they use their tablets.

3) Over a quarter of time spent on smartphones is on social networking sites. In _____, only 15% of tablet time is used for social media.

4) Younger people like shopping on their tablets, but they often use their smartphones to buy things _____.

5) Tablet users spend the majority of their time on the device playing games. _____, gaming is the top use for smartphones.

6) People use smartphones more for communication, _____ tablets are preferred for entertainment.

Part II Reading Example

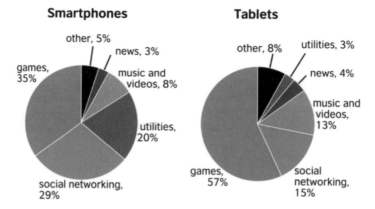

Time Spent on Smartphones and Tablets

Overall, the two pie charts show that smartphones and tablets are used for the same purposes but to very different extents.

The first pie chart shows how people spend their time on smartphones while the second pie chart illustrates how time is spent on tablets. For both types of device, the top use is for games, but the figures differ greatly. 57% of the time spent on a tablet is given to playing games, while only 35% of the time spent on a smartphone is used for this. In contrast, smartphone users spend 29% of their time on their gadget accessing social networking sites compared with just 15% of tablet time spent on the same activity.

The third most popular use of the tablet is for consuming entertainment, with users spending 13% of their tablet time watching videos and listening to music. Smartphone users, however, dedicate only 8% of their smartphone time to such entertainment, preferring instead to spend 20% of their time on their phone accessing utilities. These can include maps, weather information and calculators.

There is a clear difference in the way people are using their smartphones and

tablets. In general, while tablets are being used more for gaming and other forms of entertainment, smartphones seem to be the preferred option for tasks as well as communication with the world around us.

Tips

- Before writing about the detailed figures, give an overview of what the graphs or charts represent.
- Say precisely what the data refers to. There is a difference between, for example, a user spending 57% of *their time* on games and a user spending 57% of *their tablet time* on games. (You can write % or per cent, but be consistent.)
- You don't need to describe all the information in the diagrams. Select the most important things.
- Don't repeat vocabulary. Use different words and phrases with the same or similar meanings, e.g. *playing games = gaming*.
- Use *similarly, in the same way* or *also* to show similarities and use *however, in contrast, but, while* or *instead* to show differences.

Part III Task

The charts show the quantity of milk, in pints, consumed daily by children in the UK in 2017. Write a report describing the information shown below. You should write no more than 150 words.

Quantity of Milk Consumed Daily by Children in the UK in 2017

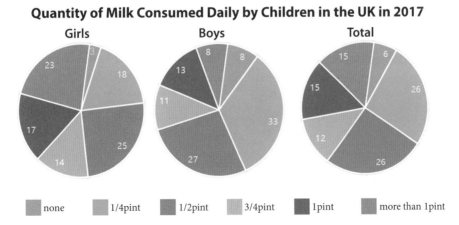

none 1/4pint 1/2pint 3/4pint 1pint more than 1pint

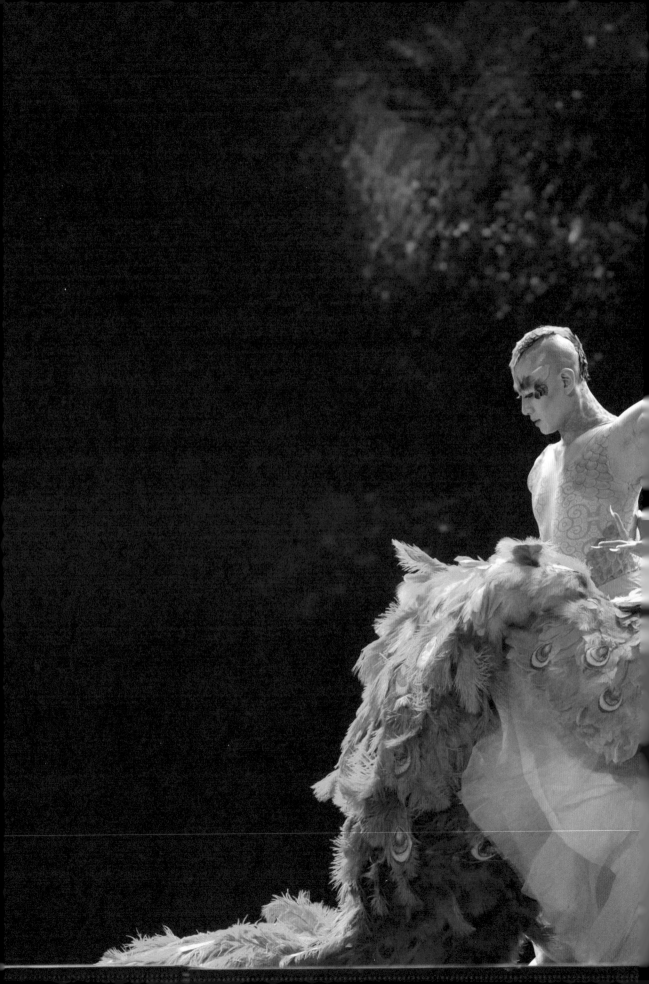

Students will be able to:

- understand the vocabulary of dancing;
- describe the words and phrases of dancing;
- gain an appreciation of folk dance and modern dance;
- write a report on the main features a table shows.

Unit **4**

World Famous
Dancers

Lead-In

Task 1 Exploring the Theme

Watch a short video clip and fill in the blanks.

This is my world: the world of ballet. Dance has 1) _____ me, giving me such 2) _____ and joy. And here is the dancer who 3) _____ all that is beautiful about the ballet. This is Margot Fonteyn. Every 4) _____, including me, has 5) _____ to be Margot. They are always trying to find the next Margot Fonteyn. Margot danced around the world and won everyone's heart. She remains the 6) _____ image of the perfect ballerina.

Task 2 Brainstorming

Watch the short video clip again and answer the following questions.

1) Have you heard of the ballerina that the speaker mentioned? Do you know anything about her?

2) Why did the speaker wonder if Margot's magic might have been a curse as well as a blessing?

Task 3 Building Vocabulary

Fill in the blanks with appropriate words given in the box. Change the form where necessary.

> choreograph choreographer inspiration repertoire debut

The company has a very extensive 1) _____ that includes not only classical programmes but also new creations by international 2) _____. *Primitive Mysteries* was 3) _____ by Martha Graham, with possible sources of 4) _____ derived from Catholic and New Mexican Pueblo culture, and its 5) _____ performance in 1931 proved to be a huge success.

Reading A

Yang Liping—a Legendary Chinese Dancer

1　One of China's renowned dancers, both at home and abroad, Yang Liping, is from the Bai **ethnic** group. She has won a reputation for being the "Spirit of Dance" due to her charming performances, such as *The Soul of the Peacock*[1], *Two Trees*[2], and *Moonlight*[3].

ethnic *adj.* （有关）种族的；民族的；少数民族的

2　Yang Liping was born in Dali in 1958. At the age of nine, Yang moved with her family to Xishuangbanna. Because of her extraordinary gift, she was chosen to join the Xishuangbanna Song and Dance Troupe[4] when she was thirteen years old. She became famous **overnight** for her performance in the Dai dance drama, *The Peacock Princess*[5]. In 1988, she entered the China Ethnic Song and Dance Ensemble[6]. At the Second National Dance Contest, her dance *The Soul of the Peacock*, which she **choreographed** and performed herself, **outshone** all the other dances and reaped two first prizes, one for

overnight *adv.* 突然；一夜之间

choreograph *v.* 设计舞蹈动作；编舞

outshine *v.* 使相形见绌；胜过

1　《雀之灵》，杨丽萍自编自演的女子独舞。
2　《两棵树》，杨丽萍创作表演的双人舞。
3　《月光》，杨丽萍创作表演的傣族独舞。
4　西双版纳歌舞团。
5　《孔雀公主》，杨丽萍主演的傣族舞剧。
6　中央民族歌舞团。

choreography and the other for her performance of the piece. A shining star was on the rise. Since then, she and her dancing have been regularly shown on television.

affection *n.* 喜爱；关爱

3 "I naturally became interested in dance," said Yang when interviewed. "The Bai people love nature and advocate the essence of life. So, they usually express their **affection** for nature and life through singing and dancing." The first time she performed the dance *The Soul of the Peacock*, Yang said, "I felt as if spiders and elephants were all around me as I stood on top of an earth mound in my hometown."

lyrical *adj.* 抒情风格的
trivial *adj.* 琐碎的；不重要的
meretricious *adj.* 俗气的；华丽而庸俗的
various *adj.* 各种各样的
silhouette *n.* 轮廓；剪影
backdrop *n.* 背景

4 Yang's dances boast a **lyrical** touch, which often abandons **trivial** realities and **meretricious** expressions. What's left in her dances are **various** moves that form **silhouettes** of a tree, a fish, a bird, or a snake against the **backdrop** of a moon as depicted in her dance *Moonlight*. It seems that Yang, with her dances, invites audiences to journey to a fairyland with blooming flowers, singing birds, and running beasts. She gives life to those creatures with her emotional and expressive body language, and communicates with them.

dub *v.* 将……戏称为；给……起绰号
sorceress *n.* 女巫；巫女
inspiration *n.* 灵感；启发灵感的人（或事物）
aboriginal *adj.* 土著的；原始的

5 Yang, a genuine artist coming from the deep mountains, has sometimes been **dubbed** the "**sorceress**" of dance. In Southeast Asia, she is also known as the "Goddess of Dance". Yang's pure and mellow dance style is a result of her unique figure, intelligence and artistic **inspirations** from the **aboriginal** and natural cultural landscape.

repertoire *n.* （表演者或表演团的）全部剧目；全部节目

6 In 2003, she left the ethnic ensemble and started out as an independent artist. Yang then directed *Dynamic Yunnan*[1], a dance drama that became a sensation. She traveled throughout the province to seek inspiration and ended up collecting not just **repertoires** of folk dances and songs but also bringing back talented folk artists, all of whom appeared in it. In 2004, *Dynamic Yunnan* won five "Lotus Awards", the highest prize for Chinese professional dances.

1 《云南映象》，杨丽萍编导的大型原生态歌舞集。

7 *Dynamic Yunnan* has been staged over 3,000 times worldwide and is now performed as a tourist attraction in Kunming, the provincial capital of Yunnan. Yang continues to craft and amend it. It has been welcomed with applause and awards worldwide and arouses fierce discussion about **primitive** songs and dances in cultural circles.

primitive *adj.* 原始的；远古的

8 *The Sound of Yunnan*[1] premiered on stage in 2009 as a companion show to *Dynamic Yunnan*. The performance put on stage various farming tools including hoes, water wheels, dustpans, and pots and pans demonstrating the Yunnan ethnic groups' creativity. After a seven-year world tour, it started to be performed regularly in Lijiang, Yunnan Province.

9 *Under Siege—The Full Story of Farewell My Concubine*[2] is a 2015 work by Yang Liping with noticeable changes from her previous creations. She added some classic Chinese elements to the performance, including Beijing Opera, martial arts, paper-cuts and installation art, to interpret the epic battle between the Chu and Han armies in 202 BC, which **altered** the course of Chinese history.

alter *v.* 改变；更改

1 《云南之声》，杨丽萍继《云南映象》之后倾力打造的姐妹篇。
2 《十面埋伏——霸王别姬全传》，杨丽萍编导的大型舞蹈剧。

debut *n.* 首次登台

hail *v.* 赞扬（或称颂）

10 Since its **debut** in 2015 in China, *Under Siege* has been widely **hailed** as an aesthetic feast and visual splendor. In 2019, Yang Liping thrilled the Big Apple with the impressive creation of *Under Siege*. "It was absolutely fabulous, visually extraordinary, and it's unlike anything I've seen before," said Jennifer, editor of a local New York magazine, after seeing the debut performance of *Under Siege* at the David H. Koch Theater[1] at the Lincoln Center in New York.

choreographer *n.* 编舞者；舞蹈指导

conceptual *adj.* 概念的；观念的

perspective *n.* （观察问题的）视角；观点；看法

manifest *v.* 显示；表明

contention *n.* 争论；争吵；争夺；竞争

11 Yang, chief **choreographer** and director, said in a previous interview that *Under Siege* is a **conceptual**, experimental piece of performance art, which she created with an international **perspective**. She attempts to cast a cold vision of the desires and fears that **manifest** in the depths of the human heart, to hurt and to be hurt, through the historical story of the Chu-Han **Contention** more than 2,000 years ago, as a reflection in today's world.

1　大卫·H·科赫剧院，位于纽约市林肯艺术中心的著名剧院。

12 "For me, it's an experiment," Yang says. "Just to show the traditional Chinese elements onstage would be copying what other people have done. So, I have melded them with a more **contemporary** way of passing the message to the audience."

contemporary *adj.* 当代的；现代的

13 "At the same time, I don't feel that the Chinese audience is ready for only **abstract** things," she says. "So there needs to be some traditional elements as well. It is a mixture of traditional and abstract. I'm striving for a Chinese way of developing contemporary art and dance on stage."

abstract *adj.* 抽象的；纯理论的；纯概念的

14 She is so close to her sources of inspiration and she has so wonderful a **grip** over her material that others pale beside her and look like pretenders. She combines the soul of Martha Graham[1] with the show of Florenz Ziegfeld[2]. This is Yang Liping, who lives for dance.

grip *n.* 掌握；控制；理解

(918 words)

(From CCTV and chinadaily websites.)

1 玛莎·葛兰姆（1894–1991），美国舞蹈家和编舞家，也是现代舞蹈史上最早的创始人之一。

2 弗洛伦兹·齐格菲尔德 (1867–1932)，美国戏剧制作人。

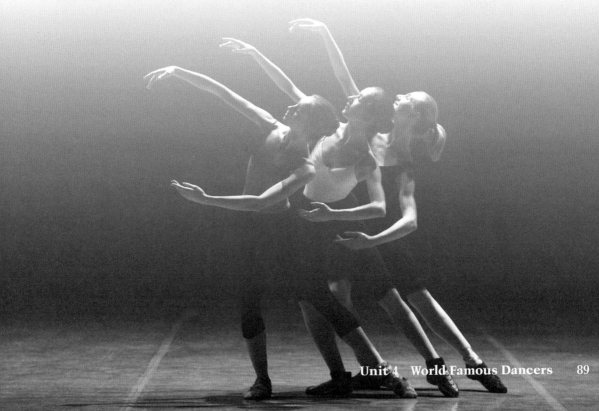

Part I　Understanding the Text

Task 1　Global Understanding

1. Read the text and identify the main idea.

1) Why is Yang Liping known as a legendary dancer?

2) Talk with your classmates and discuss the features of Yang's works.

2. Read the text and decide whether the following sentences are true (T) or false (F).

(　　) 1) Yang became famous overnight for her performance in the Dai dance drama, *The Soul of the Peacock.*

(　　) 2) Yang's dance *The Peacock Princess*, which she choreographed and performed herself, reaped two first prizes at the Second National Dance Contest.

(　　) 3) Yang then directed *Dynamic Yunnan* after she left the ethnic ensemble and started out as an independent artist.

(　　) 4) *Under Siege* manifests the desires and fears in the depths of the human heart, to hurt and to be hurt, through the historical story of the Chu-Han Contention more than 2,000 years ago.

(　　) 5) Yang is seeking a Chinese way of developing contemporary art and dance on stage, through combining tradition and abstraction.

Task 2 Detailed Understanding

1. Read the text again and choose the best answer to each question below.

1) Where did Yang Liping thrill with the impressive creation of *Under Siege* in 2019?

 A. Beijing. B. Paris.

 C. New York. D. London.

2) Which classic Chinese elements have NOT been added to *Under Siege*?

 A. Various Chinese farming tools. B. Paper-cuts.

 C. Beijing Opera. D. Martial arts.

3) Why did Yang say that *Under Siege* is a conceptual, experimental piece of performance art?

 A. Because it was the first time to show the historical story of the Chu-Han Contention on stage.

 B. Because she didn't feel that the Chinese audience was ready for abstract things.

 C. Because she added some classic Chinese elements to the performance to interpret the epic battle between the Chu and Han armies in 202 BC.

 D. Because she melded the traditional Chinese elements with a more contemporary way, and she was experimenting with a Chinese way, mixing abstraction and tradition, to develop contemporary art and dance.

2. Answer the following questions according to the text.

1) Please list all of the dances mentioned in the text.

2) Please list the following dances in chronological order: *The Soul of the Peacock, The Peacock Princess, Under Siege, Dynamic Yunnan*.

3) Which dance won five "Lotus Awards"? In which city is it performed as a tourist attraction?

Part II Building Language

Task 1 Key Terms

The following words or phrases are related to dance. Discuss with your classmates and provide your understanding about each term in English.

1) choreograph: _____

2) choreographer: _____

3) silhouette: _____

4) premiere: _____

5) repertoire: _____

6) debut: _____

7) primitive songs and dances: _____

8) contemporary art: _____

9) martial arts: _____

10) installation art: _____

Task 2 Vocabulary

Choose the correct word or phrase from the box below to complete each of the following sentences. Change the form where necessary.

overnight	outshine	affection	various	inspiration
artistic	hail	aesthetic	lyrical	sensation
conceptual	perspective	contemporary	choreograph	alter

1) Achim had _____ the dance in Act II himself.

2) _____ dance is coming onto the arts scene again after a long fallow period.

3) In 1970 he became a(n) _____ success in America.

4) Dreams can be a rich source of _____ for an artist.

5) She was held in deep _____ by all her students.

6) Can artificial intelligence (AI) _____ humans in brain power?

7) She took the job for _____ reasons.

8) His experience abroad provides a wider _____ on the problem.

9) He was the master of the modern Arabic _____ poetry who also wrote the lyrics to more than 1,000 popular Egyptian songs.

10) As with other Maori _____ traditions, kite-making involved certain rituals.

11) It is necessary that critics develop a sensibility informed by familiarity with the history of art and _____ theory.

12) He had _____ so much I scarcely recognized him.

13) Faulkner has been _____ as the greatest American novelist of his generation.

14) News of his arrest caused a(n) _____.

15) It is a technical advance, not a(n) _____ one.

Part III Translation

1. Translate the following sentences into Chinese.

1) At the Second National Dance Contest, her dance *The Soul of the Peacock*, which she choreographed and performed herself, outshone all the other dances and reaped two first prizes, one for choreography and the other for her performance of the piece.

2) Yang's dances boast a lyrical touch, which often abandons trivial realities and meretricious expressions.

3) She traveled throughout the province to seek inspiration and ended up collecting not just repertoires of folk dances and songs but also bringing back talented folk artists, all of whom appeared in it.

4) She attempts to cast a cold vision of the desires and fears that manifest in the depths of the human heart, to hurt and to be hurt, through the historical story of the Chu-Han Contention more than 2,000 years ago, as a reflection in today's world.

5) She is so close to her sources of inspiration and she has so wonderful a grip over her material that others pale beside her and look like pretenders.

2. Translate the following sentences into English.

1) 杨丽萍凭借《雀之灵》《两棵树》《云南映象》等精彩的表演和编舞赢得了"舞蹈之魂"的美誉。

2) 她的舞蹈风格纯粹而抒情，她的艺术灵感来自于土著和自然的文化景观。

3) 中国民间舞蹈最早出现于 5000 多年前，是悠久历史发展和深厚艺术文化的产物。

4) 《云南映象》是由著名舞蹈演员杨丽萍主创的舞剧，它融合了云南农村原始歌谣和民间舞蹈的精髓，呈现出一种全新的舞台艺术风格。

5) 运用传统的剪纸表演、迷人的京剧服装、大胆的武术和装置艺术，《十面埋伏》成为一部基于强大的肢体语言和真实的中国精神的当代舞蹈作品。

Reading B

Martha Graham

1 For many people, Martha Graham is "the mother of modern dance". Born at the end of the 1800s, she dominated the world of dance for decades— both as a dancer and as a choreographer, and created a whole theory and language of movement that is still used today.

2 Martha Graham was born near Pittsburgh, Pennsylvania[1] in 1894. She started dancing when she was 22 (very late for a dancer) at the Denishawn School[2] and stayed there for eight years before moving to New York City. She worked as a teacher, dancer, and choreographer before she formed the

1　（美国）宾夕法尼亚州匹兹堡。
2　丹尼肖恩舞蹈学校，位于美国洛杉矶，也是美国第一个大型的现代舞蹈团。

Martha Graham Dance Company[1] in 1926. Based in New York City, the Martha Graham Dance Company has a repertoire of over 180 dances. Her company has included famous dancers such as Alvin Ailey[2], Twyla Tharp[3], Paul Taylor[4], and Merce Cunningham[5], and her work has been performed by Margot Fonteyn[6], Rudolf Nureyev[7], Mikhail Baryshnikov[8], and Liza Minnelli[9], among others.

3 Having her own company allowed Graham to bring her ideas to life. One of her most famous works, *Primitive Mysteries*[10], deals with religion and ritual. At that time, nobody made dances about serious themes like these, but her **fascination** with American history led her to produce *Frontier*[11] and *Appalachian Spring*[12], celebrations of the American pioneers of the 19th century.

4 Martha Graham developed a special way of dancing, which used some unusual techniques. Two of these techniques were the "**contraction**" and the "**release**". They involve tightening and releasing the **abdominal muscles** while using carefully controlled breathing, and are still the basis of modern American dance. Graham's work **features** sharp, **jagged** shapes, instead of gentle, rounded lines, and sudden, **jerky** movements, rather than smooth, **sleek** ones.

5 Martha Graham's father was a doctor who **specialized** in psychology—he thought he could work out how people felt

fascination *n.* 魅力；极大的吸引力

contraction *n.* 收缩；缩小

release *n./v.* 释放；松开

abdominal muscle 腹肌

feature *v.* 以……为特色

jagged *adj.* 锯齿状的；参差不齐的

jerky *adj.* 不平稳的；急促而不流畅的

sleek *adj.* 圆滑的；光滑的

specialize *v.* 专门研究（或从事）；专攻

1 玛莎·葛兰姆舞团。
2 阿尔文·艾利，美国黑人舞蹈家和舞蹈编导。
3 特怀拉·萨普，美国著名舞蹈家、现代舞和芭蕾舞编导。
4 保罗·泰勒，美国舞蹈艺术家、舞蹈编导。
5 摩斯·肯宁汉，美国舞蹈家、编导，当代舞领袖人物之一。
6 玛戈特·芳婷，英国女芭蕾演员。
7 鲁道夫·纽瑞耶夫，俄罗斯芭蕾舞蹈家。
8 米哈伊尔·巴雷什尼科夫，著名芭蕾舞蹈家。
9 莱莎·明奈利，美国著名女演员、歌手、舞蹈演员。
10 现代舞《原始奥秘》。
11 现代舞《边疆》。
12 现代舞《阿巴拉契亚之春》。

by watching the way they moved. Dr. Graham always said, "Movement never lies," and this theory inspired his daughter's work. Martha Graham used special techniques to train her dancers. Classes began on the floor with the contraction, the release, and the **spiral**, which was a twisting of the **torso** around the **spine**. The dancers warmed up their feet and legs and began moving across the floor before they could start to put all the movements together.

spiral *n.* 螺旋；螺旋形
torso *n.* （身体的）躯干
spine *n.* 脊柱；脊椎

6 Martha Graham gave her last performance in New York City at age 74 in 1969. She died just before her 97th birthday in 1991. That was Martha Graham, a dancer and choreographer, whose **originality** and creativity have lifted her to a place high among the arts. Critics have called her the **undisputed** star of the modern world. The following is the essay written by Martha Graham, which has become the beacon for the world of modern dance since it was aired **circa** 1953.

originality *n.* 独创性；创意；创造力

undisputed *adj.* 无可争辩的；无异议的

circa *prep.* 大约；左右（主要用于日期前）

7 "I believe that we learn by practice. Whether it means to learn to dance by practicing dancing or to learn to live by practicing living, the principles are the same. In each, it is the performance of a **dedicated** precise set of acts, physical or intellectual, from which comes shape of achievement, a sense of one's being, a satisfaction of spirit. One becomes, in some area, an athlete of God. Practice means to perform, over and over again in the face of all obstacles, some act of vision, of faith, of desire. Practice is a means of inviting the perfection desired.

dedicated *adj.* 专用的；专门用途的

8 I think the reason dance has held such an ageless magic for the world is that it has been the symbol of the performance of living. Many times, I hear the phrase 'the dance of life'. It is close to me for a very simple and understandable reason.

instrument *n.* 工具；手段	The **instrument** through which the dance speaks is also the instrument through which life is lived: the human body. It is an instrument by which all the primaries of experience are made manifest. It holds in its memory all matters of life and death and love.
glamorous *adj.* 迷人的；富有魅力的	9 Dancing appears **glamorous**, easy, delightful. But the path to the paradise of that achievement is not easier than any other. There is **fatigue** so great that the body cries, even in its sleep. There are times of complete **frustration**; there are daily small deaths. Then I need all the comfort that practice has stored in my memory and a **tenacity** of faith. But it must be the kind of faith that Abraham had, wherein he 'staggered not at the promise of God through unbelief'.
fatigue *n.* 疲乏；劳累；厌倦	
frustration *n.* 懊恼；沮丧	
tenacity *n.* 韧性；执着；不屈不挠	
stagger *v.* 蹒跚；（决心）动摇	10 It takes about 10 years to make a **mature** dancer. The training is twofold. There is the study and practice of the craft in order to strengthen the muscular structure of the body. The body is shaped, **disciplined**, honored and in time, trusted. The movement becomes clean, precise, **eloquent**, truthful. Movement never lies. It is a **barometer** telling the state of the soul's weather to all who can read it. This might be called the law of the dancer's life—the law which governs its outer aspects.
mature *adj.* 成熟的；理智的	
disciplined *adj.* 训练有素的；遵守纪律的	
eloquent *adj.* 雄辩的；口才流利的	
barometer *n.* 气压计；晴雨表；变化的标志或指标	
cultivation *n.* 耕作；栽培；（品质或技巧的）培养	11 Then there is the **cultivation** of the being. It is through this that the legends of the soul's journey are re-told with all their **gaiety** and their tragedy and the bitterness and sweetness of living. It is at this point that the sweep of life catches up the **mere** personality of the performer and while the **individual** (the undivided one), becomes greater, the personal becomes less personal. And there is grace. I mean the grace resulting from faith: faith in life, in love, in people and in the act of dancing. All this is necessary to any performance in life which is **magnetic**, powerful, rich in meaning.
gaiety *n.* 快乐；愉快	
mere *adj.* 仅仅；纯粹的	
individual *adj.* 单独的；个别的；个人的	
magnetic *adj.* 磁的；磁性的	12 In a dancer there is a **reverence** for such forgotten things as the miracle of the small beautiful bones and their delicate strength. In a thinker there is a reverence for the beauty of the alert and directed and **lucid** mind. In all of us who
reverence *n.* 崇敬；尊严	
lucid *adj.* 明晰的；易懂的；头脑清楚的	

perform there is an **awareness** of the smile, which is part of the equipment, or gift, of the **acrobat**. We have all walked the high wire of circumstance at times. We recognize the gravity pull of the earth as he does. The smile is there because he is practicing living at that instant of danger. He does not choose to fall."

(1037 words)

(From: [1] Mack L. *Dance from Ballet to Breakin' Step into the Dazzling World of Dance*. New York: DK Publishing, 2012. [2] npr website.)

awareness *n.* 知道；认识；意识；觉悟

acrobat *n.* 杂技演员；特技演员

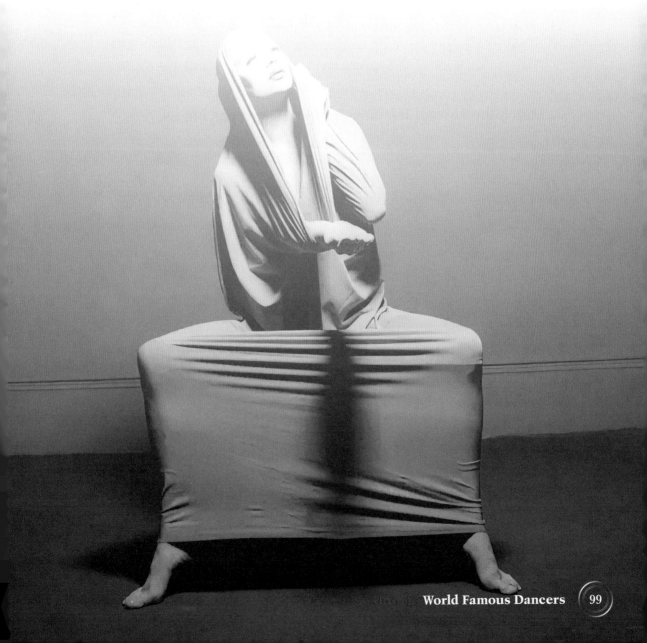

Part I — Understanding the Text

Task 1 Global Understanding

1. Read the text and identify the main idea.

1) Why is Martha Graham known as "the mother of modern dance"?

2) Can you list some of her masterpieces and their themes?

2. Match the correct headings to the paragraphs below.

Paragraph 2 A. Teaching Methods

Paragraph 3 B. A Dancer's Life

Paragraph 4 C. Typical Works

Paragraph 5 D. Dancing Techniques and Features

Task 2 Detailed Understanding

1. Read the text again and choose the best answer to each question below.

1) Which of her dance works deals with religion and ritual?

 A. *Frontier*. B. *Appalachian Spring*.

 C. *Primitive Mysteries*. D. *Night Journey*.

2) How long did Martha Graham think it took a dancer to mature?

 A. 5 years. B. 10 years.

 C. 15 years. D. 20 years.

3) Which statement is NOT TRUE about Martha Graham?

 A. It was very late for her to start dancing.

 B. She worked as a dancer, choreographer and teacher.

 C. Her father was a psychologist.

 D. *Frontier* and *Appalachian Spring* were created in memory of the American pioneers of the 19th century.

2. Answer the following questions according to the text.

1) What do the two techniques "contraction" and "release" mean in Graham's dances?

2) How do you understand "movement never lies"?

3) What is the meaning of "the dance of life" in Paragraph 8, as Martha Graham understood?

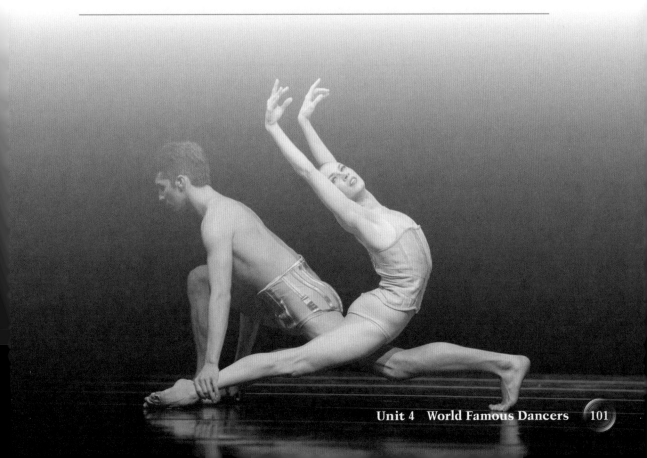

Part II Building Language

Task 1 Key Terms

The following words or phrases are related to dance. Discuss with your classmates and provide your understanding about each term in English.

1) movement: _____

2) ritual: _____

3) technique: _____

4) contraction: _____

5) release: _____

6) abdominal muscles: _____

7) jagged shapes: _____

8) jerky movement: _____

9) sleek movement: _____

10) spiral: _____

11) torso: _____

12) instrument: _____

13) barometer: _____

14) acrobat: _____

Task 2 Vocabulary

Choose the correct word from the box below to complete each of the following sentences. Change the form where necessary.

fascination	aware	individual	lucid	eloquent
cultivation	mature	glamorous	dispute	reverence
discipline	ritual	tenacity	mere	fatigue

1) It took her a(n) _____ 20 minutes to win.

2) For me it meant being very _____ about how I run my life.

3) I've had a lifelong _____ with the sea and small boats.

4) He gave students a(n) _____ account of the history of mankind.

5) Talent, hard work and sheer _____ are all crucial to career success.

6) It is important that students develop a(n) _____ of how the Internet can be used.

7) We interviewed each _____ member of the community.

8) I heard him make a very _____ speech at that dinner.

9) The old lady can't bear the _____ of a long journey.

10) This is the most ancient, and holiest of the Buddhist _____ .

11) High schools should lay emphasis on the _____ of students' interpersonal communication skills.

12) They are emotionally _____ and should behave responsibly.

13) A lot of people believe that working at a magazine is a(n) _____ job.

14) Seles won 10 tournaments, and was the _____ world champion.

15) The poem conveys his deep _____ for nature.

Part III Translation

1. Translate the following sentences into Chinese.

1) At that time, nobody made dances about serious themes like these, but her fascination with American history led her to produce *Frontier* and *Appalachian Spring*, celebrations of the American pioneers of the 19th century.

2) That was Martha Graham, a dancer and choreographer, whose originality and creativity have lifted her to a place high among the arts. Critics have called her the undisputed star of the modern world.

3) The instrument through which the dance speaks is also the instrument through which life is lived: the human body. It is an instrument by which all the primaries of experience are made manifest.

4) Movement never lies. It is a barometer telling the state of the soul's weather to all who can read it. This might be called the law of the dancer's life—the law which governs its outer aspects.

5) Then there is the cultivation of the being. It is through this that the legends of the soul's journey are re-told with all their gaiety and their tragedy and the bitterness and sweetness of living.

2. Translate the following sentences into English.

1) 她把现代舞在美国文化中的受欢迎程度提高到一个新的水平。她创造了一种新的运动语言，表达了强烈的情感。

2) 她把自己的身体训练得足够强壮，以满足舞蹈的高难度要求。

3) 为了自由地表达自己，她决定成立自己的舞蹈团和学校。1926 年，她创办了玛莎·葛兰姆当代舞蹈中心。

4) 葛兰姆的舞蹈富有张力。有些动作包括收缩和放松身体的某些部位，用手臂做戏剧性的动作，然后倒地。这些动作至今仍在现代舞中使用。

5) 1998 年，《时代》杂志将玛莎·葛兰姆列为"世纪舞者"，并将其列为 20 世纪最重要的人物之一。

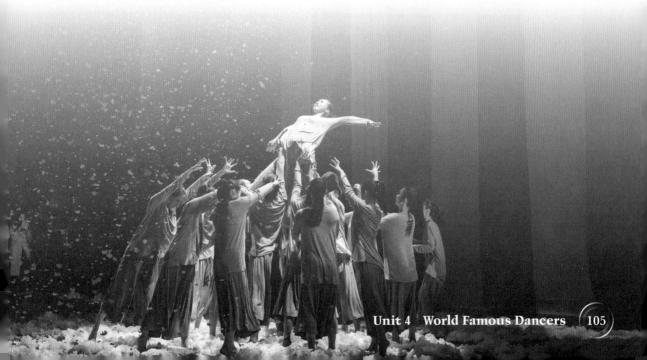

Writing Skills

Describing a Table and Writing a Report on the Main Features It Shows

Part I Preparation

Task 1 Introduction

Describing a table is similar to describing charts or graphs. The same structures of comparison and contrast are used or language of change can be employed if the table is over time. A table is just another way to present information.

There are three basic steps for you to describe a table:

1. Introduce the table. You need to begin with one or two sentences that state what the table shows.

2. Give an overview. You also need to state what the main trend or trends are shown in the table. Don't give details such as data here—you are just looking for something that describes what is happening overall.

3. Give the details. You can now give more specific details in the body paragraphs.

Task 2 Preparation Task

The following is an example of how to summarize information of a table. Fill in the blanks with appropriate words and phrases given in the box.

similarly	change	an overall rise	doubled	equivalent figures
higher proportions	falls	fell	reduce	whereas

The table compares two primary schools in terms of the proportions of their pupils who experienced seven different educational problems in the years 2005 and 2015.

Percentage of Children with Different Educational Problems in Two Primary Schools

Problems	2005		2015	
	School A	School B	School A	School B
Reading	22	8	23	9
Handwriting	28	7	28	7
Spelling	30	5	25	10
Listening skills	35	11	20	12
Verbal expression of ideas	35	14	21	15
Concentration in lessons	40	15	18	15
Following instructions	42	6	18	12

It is noticeable that school A had 1) _____ of children with all seven educational difficulties in both years. However, while school A managed to 2) _____ the incidence of most of the problems between 2005 and 2015, school B saw 3) _____ in the percentage of children who were struggling.

In 2005, 42% of school A's pupils found it difficult to follow instructions, 4) _____ only 6% of pupils in school B experienced this problem. 5) _____, between 30 and 40 per cent of children attending school A had problems in spelling, listening, verbal expression and concentration in lessons, while the 6) _____ for school B stood at between 5 and 15 per cent.

In 2015, the difference between the two schools was less pronounced. Notably, the proportion of children who struggled to follow instructions 7) _____ by 24% in school A, and this school also saw 8) _____ of 22%, 15%, 14% and 5% in the figures for children who had problems with concentration, listening, verbal expression and spelling. In school B, however, the proportions of children who struggled with spelling and following instructions 9) _____, to 10% and 12% respectively, and there was almost no 10) _____ in the incidence of listening, verbal or concentration problems.

Part II Reading Examples

Example 1

The table below shows data about the underground rail networks in six major cities.

City	Date opened	Kilometers of route	Passengers per year (in millions)
London	1863	394	775
Paris	1900	199	1191
Tokyo	1927	155	1927
Washington DC	1976	126	144
Kyoto	1981	11	45
Los Angeles	2001	28	50

The table compares the six rail networks in terms of their age, size and the number of people who use them each year. It is clear that the three oldest underground systems are larger and serve significantly more passengers than the newer systems.

The London underground is the oldest system, which opened in 1863. It is also the largest system, with 394 kilometers of route. The second largest system, in Paris, is only about half the size of the London underground, with 199 kilometers of route. However, it serves more people per year. While only third in terms of size, the Tokyo system is obviously the most used, with 1927 million passengers per year.

Of the three newer networks, the Washington DC underground is the most extensive, with 126 kilometers of route, compared to only 11 kilometers and 28 kilometers for the Kyoto and Los Angeles systems. The Los Angeles network is the newest, which opened in 2001, while the Kyoto network is the smallest and serves only 45 million passengers per year.

Example 2

The table below shows the amounts of waste production (in millions of tonnes) in six different countries over a twenty-year period.

Country	1980	1990	2000
Ireland	0.6	*	5
Japan	28	32	53
Korea	*	31	19
Poland	4	5	6.6
Portugal	2	3	5
US	131	151	192

* Figure not available

The table compares the amounts of waste that were produced in six countries in the years 1980, 1990 and 2000.

In each of these years, the US produced more waste than Ireland, Japan, Korea, Poland and Portugal combined. It is also noticeable that Korea was the only country that managed to reduce its waste output by the year 2000.

Between 1980 and 2000, waste production in the US rose from 131 to 192 million tonnes, and rising trends were also seen in Japan, Poland and Portugal. Japan's waste output increased from 28 to 53 million tonnes, while Poland and Portugal saw waste totals increase from 4 to 6.6 and from 2 to 5 million tonnes respectively.

The trends for Ireland and Korea were noticeably different from those described above. In Ireland, waste production increased more than eightfold, from only 0.6 million tonnes in 1980 to 5 million tonnes in 2000. Korea, by contrast, cut its waste output by 12 million tonnes between 1990 and 2000.

- This is a report so you mustn't write about your opinion—only facts.
- Choose the most important points to write about first.
- Don't insert any examples from your life and do not judge whether something is good or bad.
- You do not have to explain why some increase or decrease took place—it is out of the question.
- Make it easy to read. you should always group information in a logical way to make it easy to follow and read.
- Vary your language. You should not keep repeating the same structures.

Part III Task

Look at the table below. Please write a report to describe the information in the table. You should write at least 150 words.

The table compares the percentages of people using different functions of their mobile phones between 2006 and 2010.

Percentages of Mobile Phone Owners Using Various Mobile Phone Features

Mobile phone function	2006	2008	2010
Make calls	100	100	99
Take photos	66	71	76
Send and receive text messages	73	75	79
Play games	17	42	41
Search the Internet	no data	41	73
Play music	12	18	26
Record video	no data	9	35

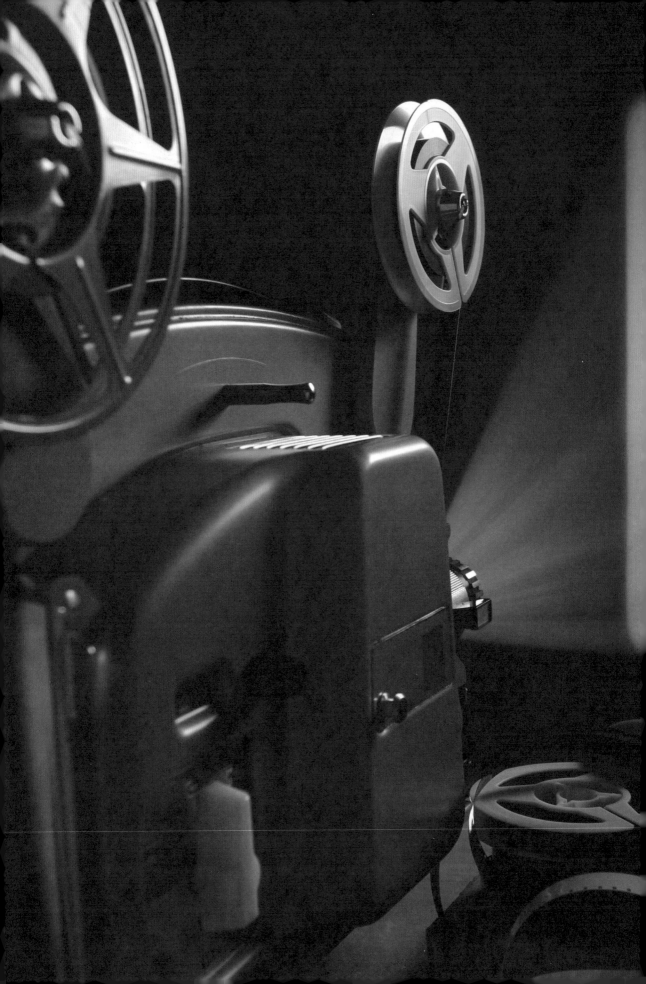

Learning Objectives

Students will be able to:

- ✅ understand the vocabulary related to film shooting;
- ✅ describe the life stories of certain movie directors;
- ✅ gain an appreciation of the works of film production;
- ✅ write a formal email to a university professor.

Unit **5**

Innovators of the
Cinema

Lead-In

Task 1 **Exploring the Theme**

Look at the pictures and answer the questions.

What are the names of the film awards? Which film festival does each of them belong to?

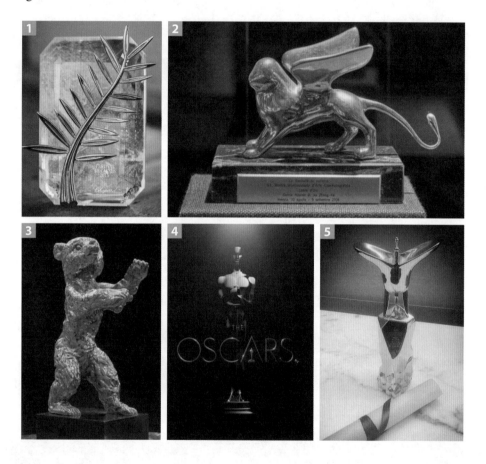

Task 2 **Brainstorming**

Answer the following questions. Discuss with your classmates and share your answers with the class.

1) What are the three most important factors when you evaluate a film?

2) What do you think of film piracy? What can be done to prevent the spread of pirated movies?

Task 3 Building Vocabulary

Choose the right word to fill in the blank of each sentence. Change the form where necessary.

> substitute perspective innovation convict sophisticated

1) From my _____, the project manager is very cost-conscious.

2) The man was _____ of fraud charge and information leakage.

3) Jack has become confident and _____ after graduation.

4) The company has gained the competitive edge through the technological _____.

5) The recipe says you can _____ yoghurt for the sour cream.

Reading A

Georges Méliès, Magician of the Cinema

1 Méliès was a performing magician who owned his own theater. After seeing the Lumière Cinématographe[1] in 1895, he decided to add films to his program, but the Lumière brothers were not yet selling machines. In early 1896, he obtained a projector from English inventor R.W. Paul and by studying it he was able to build his own camera. He was soon showing films at his theater.

Georges Méliès

2 Although Méliès is remembered mainly for his delightful

1　卢米埃尔兄弟（电影摄影术先驱）的电影摄放机。

fantasy movies, **replete** with camera tricks and painted **scenery**, he made films in all the **genres** of the day. His earliest works, most of which are lost, included many Lumière style scenics and brief comedies, filmed outdoors. During his first year of production, he made seventy-eight films, including his first trick film, *The Vanishing Lady*[1]. In it, Méliès appears as a magician who **transforms** a woman into a skeleton. The trick was accomplished by stopping the camera and **substituting** the skeleton for the woman. Later, Méliès used **stop-motion** and other special effects to create more complex magic and fantasy scenes. These tricks had to be accomplished in the camera, while filming; prior to the mid-1920s, few laboratory manipulations were possible. Méliès also acted in many of his films, recognizable as a **dapper** and **spry** figure with a bald head, moustache, and pointed beard.

3　　In order to be able to control the **mise-en-scène** and **cinematography** of his films, Méliès built a small glass-enclosed studio. Finished by early 1897, the studio permitted Méliès to design and construct sets painted on canvas flats. Even working in this studio, however, Méliès continued to create various kinds of films. In 1898, for example, he filmed some reconstructed topicals, such as *Divers at Work on the Wreck of the "Maine"*[2]. His 1899 film, *The Dreyfus Affair*[3], told the story of the Jewish officer **convicted** of **treason** in 1894 on the basis of false evidence put forth through antisemitic motives. The controversy was still raging when Méliès made his pro-Dreyfus picture. As was customary at the time, he released each of the ten shots as a separate film. When shown together, the shots combined into one of the most complex works of the cinema's early years. (Modern prints of *The Dreyfus Affair* typically combine all the shots in a single **reel**.) With his next work, *Cinderella*[4], Méliès began joining multiple shots and selling

replete *adj.* 充满的；充足的

scenery *n.* 舞台布景

genre *n.* （文学、艺术、电影或音乐的）体裁；类型

transform *v.* 使改变形态

substitute *v.* （以……）代替；取代

stop-motion *n.* （摄影中，为了拍摄活动人物的动感照片而运用的）时停时拍的摄影技巧

dapper *adj.* 衣冠楚楚的

spry *adj.* （老人）充满活力的；活跃的

mise-en-scène *n.* <法> 舞台的布景、道具等；场面调度

cinematography *n.* 电影摄制艺术；电影制作方法

convict *v.* 定罪；宣判……有罪

treason *n.* 危害国家罪；叛国罪

reel *n.* （一部影片的）一盘；一卷（录影带）

1　电影《消失的女人》（1896）。

2　电影《潜水员在"缅因号"残骸上工作》（1898）。

3　电影《德雷福斯事件》（1899）。

4　电影《灰姑娘》（1899）。

them as one film.

4 Méliès' films, and especially his fantasies, were extremely popular in France and abroad, and they were widely imitated. They were also commonly **pirated**, and Méliès had to open a sales office in the United States in 1903 to protect his interests. Among the most celebrated of his films was *A Trip to the Moon*[1]. It was a comic science-fiction story of a group of scientists traveling to the moon in a space **capsule** and escaping after being taken prisoner by a race of creatures living under the ground. The film's style, like that of most of Méliès' other films, is theatrical. The stage set is highly stylized, recalling the traditions of the 19th-century stage, and is filmed by a **stationary** camera, placed to evoke the **perspective** of an audience member sitting in a theatre. This stylistic choice was one of Méliès' first and biggest **innovations**. Apart from that, Méliès often enhanced the beauty of his **elaborately** designed mise-en-scène by using hand-applied **tinting**.

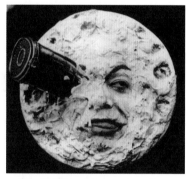

A Trip to the Moon (1902)

5 When asked in 1930 what inspired him for *A Trip to the Moon*, Méliès credited Jules Verne's novels *From the Earth to the Moon* and *Around the Moon*[2]. Cinema historians, the mid-20th-century French writer Georges Sadoul first among them, have frequently suggested H. G. Wells' *The First Men in the Moon*[3], a French translation of which was published a few months before Méliès made the film, as another likely influence.

6 Though Méliès' films were silent, they were not intended to be seen silently; exhibitors often used a narrator to explain the story as it unfolded on the screen, accompanied by sound

pirate *v.* 盗用；盗版

capsule *n.* 太空舱

stationary *adj.* 静止的；固定的

perspective *n.* 态度；观点；思考方法

innovation *n.* （新事物、思想或方法的）创造；创新；改革

elaborately *adv.* 精巧地；苦心经营地

tinting *n.* 色调

1 电影《月球旅行记》(1902)。
2 儒勒·凡尔纳的小说《从地球到月球》和《环绕月球》。
3 小说《首先登上月球的人们》。

effects and live music. Méliès himself took considerable interest in **musical accompaniment** for his films, and prepared special film **scores** for several of them, including *The Kingdom of the Fairies*[1] and *The Barber of Seville*[2]. When the film *A Trip to the Moon* was **screened** at the Olympia music hall in Paris in 1902, an original film score was reportedly written for it.

musical accompaniment 音乐伴奏

score *n.*（电影或戏剧的）配乐

screen *v.* 放映

7 Except in Méliès' first years of production, many of his films involved **sophisticated** stop-motion effects. Devils burst out of a cloud of smoke, pretty women vanish, and leaping men change into demons in midair. Some historians have criticized Méliès for depending on static theatrical sets instead of editing. Yet recent research has shown that in fact his stop-motion effects also utilized editing. He would cut the film in order to match the movement of one object perfectly with that of the thing into which it was transformed. Such cuts were designed to be unnoticeable, but clearly Méliès was a master of one type of editing.

sophisticated *adj.* 复杂巧妙的；先进的；精密的

8 For a time, Méliès' films continued to be widely successful. After 1905, however, his fortunes slowly declined. His tiny firm was hardly put to supply the **burgeoning** demand for films, especially in the face of competition from bigger companies. He continued to produce quality films, including his late masterpiece *Conquest of the Pole*[3], but eventually these came to seem old-fashioned as filmmaking **conventions** changed. In 1912, deep **in debt**, Méliès stopped producing, having made 510 films (about 40 percent of which survive). He died in 1938, after **decades** of working in his wife's candy and toy shop.

burgeoning *adj.* 激增的；迅速发展的

convention *n.* 习俗；常规；惯例

in debt 欠债

decade *n.* 十年；十年期

(923 words)

(From: Thompson K. & Bordwell D. *Film History: An Introduction*, 4th Edition. New York: McGraw-Hill Education, 2019.)

1　电影《仙女国》（1903）。

2　电影《塞维利亚的理发师》（1904）。

3　电影《征服极地》（1912）。

Part I Understanding the Text

Task 1 Global Understanding

1. Read the text and identify the main ideas.

1) What is the text mainly about?

2) Why is Méliès called the magician of the cinema according to your understanding of the text?

2. Read the text and decide whether the following sentences are true (T) or false (F).

() 1) Méliès' earliest works, most of which are lost, included many Lumière style scenics and brief comedies, filmed inside a building.

() 2) Méliès showed the 10 shots of the film *The Dreyfus Affair* which combined into one of the most complex works of the cinema's early years.

() 3) The style he used in *A Trip to the Moon* became one of the Méliès' first and biggest innovations.

() 4) Méliès' films remained silent without any help of sound effects or live music.

() 5) Faced with competition from bigger companies, Méliès' tiny films couldn't meet the increasing needs of the audience.

Task 2 Detailed Understanding

1. Read the text again and choose the best answer to each question below.

1) Why did Méliès open a sales office in the United States in 1903?

 A. His films were wildly popular in France and abroad.

 B. Because he wanted to be a salesman.

 C. He thought that it would make a profit.

 D. His films were commonly pirated, so he wanted to protect his interest.

2) Méliès' films were not intended to be seen silently except by _____.

 A. creating an audible tape to the film

 B. using a narrator to explain the story

 C. utilizing sound effects and live music

 D. adding special film scores for several of the films

3) Why did his quality films seem old-fashioned?

 A. He could not meet the needs of the audience.

 B. Film conventions have altered.

 C. He was deep in debt.

 D. His fortunes slowly declined.

2. Discuss the following questions with your partner.

1) Why did Méliès build a small glass-enclosed studio?

2) What factors do you think contributed to Méliès' success in the film domain?

3) Try to list the personality traits of a successful person you know.

Part II Building Language

Task 1 Key Terms

The following words are related to film. Discuss with your classmates and provide your understanding about each term in English.

1) mise-en-scène: _____

2) cinematography: _____

3) genre: _____

4) stop-motion: _____

5) reel: _____

6) score: _____

7) studio: _____

8) tinting: _____

9) scenery: _____

10) screen: _____

Task 2 Vocabulary

Replace the underlined parts in the following sentences with the expressions below that best keep the original meaning. Change the form where necessary.

perspective	sophisticated	scenery	transform	convention
innovation	a decade	convict	genre	burgeoning

1) The <u>natural landscape</u> is breathtaking, a unique combination of mountains, valleys, and lakes.

2) She was <u>changed</u> from a malnourished poor girl to a famous actress in just 5 years.

3) Nancy was <u>guilty</u> of shoplifting and robbery.

4) This movie is thrilling from my friend's <u>point of view</u>.

5) The key to a firm's survival in this modern world is <u>creativity</u>.

6) The team has completed the mission with the help of the <u>complex</u> equipment.

7) A conqueror will impose the old <u>tradition</u> on the people in the colony.

8) This village has become prosperous and thriving after <u>10 years</u>.

9) The spy thriller is a very special <u>type</u> of film.

10) The supply of the market cannot meet the <u>rapidly increasing</u> demand of the customers.

Part III Translation

1. Translate the following sentences into Chinese.

1) Later, Méliès used stop-motion and other special effects to create more complex magic and fantasy scenes.

2) In order to be able to control the mise-en-scène and cinematography of his films, Méliès built a small glass-enclosed studio.

3) When shown together, the shots combined into one of the most complex works of the cinema's early years.

4) Apart from that, Méliès often enhanced the beauty of his elaborately designed mise-en-scène by using hand-applied tinting.

5) Some historians have criticized Méliès for depending on static theatrical sets instead of editing.

2. Translate the following sentences into English.

1) 他的奇幻电影在国内外都极受欢迎。

2) 几年时间他从一个害羞胆小的男孩转变成一个自信的电影导演。

3) 他的低成本电影无法满足观众对于高质量电影日渐增长的需求。

4) 梅里爱添加了特殊的电影配乐使其电影更加生动有趣。

5) 导演将这个年轻有为的男演员替换了那个不负责任的老演员。

Reading B

Zhang Yimou
—One of the Most Crossover Directors in China

1 Born in Xi'an, Northwest China's Shaanxi Province in April 1950, famed Chinese director Zhang Yimou has **stood witness to** decades of changes in China's film industry. The **emergence** of the "Fifth Generation"[1] filmmaking is widely considered a **milestone** in the history of Chinese cinema, which reflected both collective and individual efforts of the 1982 graduates from Beijing Film Academy[2]. As a **prominent** member of China's "Fifth Generation" of filmmakers, Zhang Yimou wasted no time in pursuing his passion for film and helped **popularize** Chinese film around the world with works such as *Raise the Red Lantern*, *The Story of Qiuju*, *Hero*, and *House of Flying Daggers*[3]. His films have won prizes at the Cannes Film Festival[4], the

stood witness to 作为……的证人

emergence *n.* 浮现；出现

milestone *n.* 里程碑

prominent *adj.* 重要的；著名的；杰出的

popularize *v.* 宣传；普及

1　第五代导演：20 世纪 80 年代从北京电影学院毕业的年轻导演。

2　北京电影学院。

3　电影《大红灯笼高高挂》（1991）、《秋菊打官司》（1992）、《英雄》（2002）和《十面埋伏》（2004）。

4　戛纳国际电影节。

Venice Film Festival[1] and the Berlin International Film Festival[2], and six of his films have been nominated for Academy Awards[3].

Early Films—Explorations of the "Fifth Generation"

textile *n.* 纺织品

2 "I have so many stories with our country, and the things that influenced me the most would be the reform and opening-up policy and the gaokao exams. For our generation, going to the Beijing Film Academy was a life-changing opportunity. It was a gift of the times," said Zhang. "I probably would have been a worker in a textile factory in Xianyang (Shaanxi Province) and would have retired by now if there was no gaokao." "If you don't know what you can do or what potential you have, how could you even know that you can be a director?" He stated. "Therefore, the era bestowed on me a new life and opportunity."

potential *n.* 潜力；可能性

bestow on 给予；授予；献给

3 After graduation, Zhang Yimou became known as the

1　威尼斯国际电影节。

2　柏林国际电影节。

3　奥斯卡金像奖。

best cameraman in China. *Yellow Earth*[1], a film he made with another "Fifth Generation" director, Chen Kaige, won eleven international awards. In 1986 he played a peasant in Wu Tianming's *Old Well*[2], which brought him the title of best actor at the 1987 Tokyo International Film Festival[3] and the opportunity to make his own film. He made his directorial debut in 1987 with the now-classic *Red Sorghum*[4]. The film won international praise and was awarded the Golden Bear at the Berlin Film Festival in 1988. Two years later, his *Judou*[5] received the Luis Buñuel Award[6] at the Cannes Film Festival. At the 1992 Venice Film Festival, with *The Story of Qiuju*, Zhang Yimou received the Golden Lion. Since *Yellow Earth*, Zhang Yimou's films have won more than 40 awards.

4　His films **are** particularly **noted for** their rich use of color, as can be seen in some of his films. The most noteworthy feature is perhaps the red color in most of Zhang Yimou's early films: red sorghum (*Red Sorghum*), red silk (*Judou*), red lantern (*Raise the Red Lantern*), red dress (*The Story of Qiuju*), and so on. All **sensuous**, all **symbolic**. Classical Chinese theater is full of color symbols: a red face suggests loyalty; a black face, bravery; and a white face, evil. New China inherited some old color symbolism and created some new color symbols, among which red is by far the most important.

be noted for 因……而闻名

sensuous *adj.* 愉悦感官的

symbolic *adj.* 使用象征的；作为象征的；象征性的

Creating Miracles—a Crossover Director in China

5　"I am probably one of the most **crossover** directors in China," said Zhang Yimou, "Doing things in different fields is all about learning, and things related to art can be **integrated** and interacted with. Your ideas, accomplishments and

crossover *n.*（活动范围或风格的）改变；转型

integrate *v.*（使）合并；成为一体

1　电影《黄土地》(1984)。

2　电影《老井》(1986)。

3　东京国际电影节。

4　电影《红高粱》(1988)。

5　电影《菊豆》(1990)。

6　路易斯·布努埃尔特别奖。

familiarities with information and resources will all be reflected in your works."

6 Zhang Yimou was in charge of the Opening and Closing Ceremonies of the 2008 Summer Olympic Games in Beijing. The renowned director impressed the whole world for promoting Chinese traditional culture as well as modern Chinese civilization at the grand show. The International Olympic Committee has recognized that it is **unparalleled** among all other openings. Years have passed **in a flash** since that event, and to the world's expectation, China again has succeeded in holding the Winter Olympic Games soon, making Beijing the only city and the Bird's Nest the only stadium in the world to hold both Summer and Winter Olympic Games.

unparalleled *adj.* 无比的；无双的

in a flash 转瞬；一瞬间

miracle *n.* 奇迹；不平凡的事

7 "This is a **miracle** created by the Chinese people," Zhang exclaimed, "It wasn't easy for the Chinese people to achieve such a thing," said Zhang. "China suddenly had such an opportunity to show itself to the world in the process of the reform and opening-up, which gave us a unique feeling that it could only have happened during that specific time and is not something that can be repeated. A performance represents your culture, your **posture** and the development of the country."

posture *n.* 态度；看法；姿势

aesthetic *adj.* 审美的；有审美观点的；美学的

gala *n.* 庆典；盛会；演出

backdrop *n.* （喻）背景

8 The crossover director also made other contributions to show Chinese culture from his **aesthetic** understandings. A team led by Zhang also produced a **gala** based on his *Impression of West Lake Show*[1], a performance that combines music, dance and a light show with the lake as a natural **backdrop**, for the first night of the G20 Summit in Hangzhou in 2016.

Homegrown Films—a Showcase of Local Culture

9 Zhang Yimou stated that he intends to keep up with today's rapidly changing society, and that modern technology and new ideas are the measures by which he can keep his works fresh. "China is quickly becoming the world's largest box office

1 晚会《印象西湖》。

and film market, so blockbusters will continue appearing on Chinese screens," the director noted. "It sets higher standards for Chinese filmmakers to produce more excellent and diversified works that are worthy of the market."

blockbuster *n.* 一鸣惊人的事物；（尤指）非常成功的书（或电影）

diversified *adj.* 多样化的

10 "Hollywood does not represent the highest standard," said Zhang. "I think it is more important to study how to make movies in our own land and environment. Although film is a product of globalization, it is more a showcase of local culture, so Chinese filmmakers should understand traditional Chinese culture, Chinese people and Chinese society and create our own good works on our own land," Zhang stated.

showcase *n.* 展示场所（或场合）

11 Zhang noted that blockbusters such as *Wolf Warrior* 2, *The Wandering Earth*, *Ne Zha: I'm the Destiny* and *Dying To Survive*[1] are very typical Chinese movies, and the reason why Chinese audiences like them is that they are just like Chinese food to Chinese people. "These movies express our feelings and spirit," said Zhang. "We should make the best of us and have our own standard rather than following Hollywood's US standard," Zhang noted. "China's movies will naturally influence the world when China and China's movie industry become strong."

(1040 words)

(From: [1] GLOBAL TIMES website. [2] Ye T. & Zhang Y. From the Fifth to the Sixth Generation: An Interview with Zhang Yimou. *Film Quarterly* (53), 1999: 2–13.)

1 电影《战狼 2》（2017）、《流浪地球》（2019）、《哪吒之魔童降世》（2019）和《我不是药神》（2018）。

Part I Understanding the Text

Task 1 Global Understanding

1. Answer the following questions. Discuss with your classmates and share your answers with the class.

1) What films have you seen directed by Zhang Yimou? Can you describe the storyline of the films?

2) What is your understanding of the "crossover directors" from the title?

2. Write down the key idea of each paragraph below.

Paragraph 4: _____

Paragraph 8: _____

Paragraph 10: _____

Task 2 Detailed Understanding

1. Answer the following questions according to the text.

1) What is widely considered as a milestone in the history of Chinese cinema?

2) Why did the International Olympic Committee say "it is unparalleled among other openings" in Paragraph 6?

3) What should Chinese filmmakers do to create good works?

2. Discuss the following questions with your partner.

1) What would Zhang Yimou become if there was no gaokao?

2) Why are Chinese directors put on higher demands in the new era?

3) Why should we have our own standard rather than following Hollywood's US standard?

Part II Building Language

Task 1 Key Terms

The following words or phrases are related to film. Discuss with your classmates and provide your understanding about each term in English.

1) nominate: _____

2) gala: _____

3) cameraman: _____

4) debut: _____

5) performance: _____

6) homegrown films: _____

7) box office: _____

8) filmmaker: _____

Task 2 Vocabulary

Choose the correct word from the box below to complete each of the following sentences. Change the form where necessary.

integrate	symbolic	miracle	potential	debut
unparalleled	prominent	popularize	bestow	aesthetic
emergence	posture	backdrop	diversified	showcase

1) The book has enjoyed a success _____ in recent publishing history.

2) The trees will blend with the environment and _____ into the landscape.

3) This elegant woman is _____ of simplicity and kindness.

4) The film will make its world _____ next week.

5) The city is growing and thriving rapidly with full _____ .

6) The programme did much to _____ little-known writers.

7) He wished to _____ great honors on the hero.

8) The painting is outstanding from the _____ perspective.

9) He has transformed from an underdog into a(n) _____ figure.

10) We should still believe the existence of _____ in life.

11) The English teacher has shown us her _____ teaching methods which include various strategies and techniques.

12) The _____ of social media greatly facilitates the efficiency of human communication.

13) The movie is about a story of love against a(n) _____ of war and despair.

14) The new musical concert is a good _____ for her talents.

15) Poor _____ can lead to muscular problems and nearsightedness.

Part III Translation

1. Translate the following sentences into Chinese.

1) Born in Xi'an, Northwest China's Shaanxi Province in April 1950, famed Chinese director Zhang Yimou has stood witness to decades of changes in China's film industry.

2) As a prominent member of China's "Fifth Generation" of filmmakers, Zhang Yimou wasted no time in pursuing his passion for film.

3) New China inherited some old color symbolism and created some new color symbols, among which red is by far the most important.

4) Zhang Yimou stated that he intends to keep up with today's rapidly changing society, and that modern technology and new ideas are the measures by which he can keep his works fresh.

5) It sets higher standards for Chinese filmmakers to produce more excellent and diversified works that are worthy of the market.

2. Translate the following sentences into English.

1) 这个角色象征的是中国女性不畏苦难的精神。

2) 影迷们围着售票处试图购买这部大片的电影票。

3) 作为一位中国著名导演，张艺谋指出国产电影要将中国文化推向世界。

4) 这位年轻的女演员在新上演的喜剧里首次登台演出。

5) 他忙着向外国游客普及中国文化。

Writing Skills

Writing an Email to Your University Professor

Part I Preparation

Task 1 Introduction

Many college students find it necessary to email their professors occasionally. It's important to remember that emails to professors should be more formal than emails to friends and family members. Writing concisely and providing effective subject lines（标题行，主题栏）is essential. If you don't know your professor well, she/he may judge you solely by your emails. The following guide will help you make a good impression by sending professional and polite emails.

- filling the subject lines properly;
- using proper salutations（称谓）;
- avoiding slangs（俚语）;
- being concise and polite;
- avoiding grammar and punctuation mistakes;
- closing with a proper ending.

Match the vocabulary with the more formal way of saying the same thing.

Vocabulary		More Formal Vocabulary	
1)	at the moment	A	to inform you
2)	a problem	B	to request
3)	to tell you	C	an issue
4)	to talk about it more	D	concerned
5)	worried	E	currently
6)	to ask for	F	to discuss the matter further
7)	to make sth. clear	G	to clarify
8)	working hours	H	office hours

Part II Reading Example

Example

Subject: Beth Torn: Request Permission to Defer (延期) Course

Dear Professor Lynn,

My name is Beth Torn. I am a student in your class Introduction to Film Art. I am writing to inform you that, unfortunately, I am unable to continue to attend this course this semester. I would like to request permission to defer as I understand that this is only possible with your approval.

The issue is that I am currently doing an internship with ABC Ltd. It started in July and will continue until the end of the semester. The internship takes up 25 hours per week and I am concerned that it does not leave me with enough time to study. I have already asked if I can reduce my hours there, but this is not possible.

With your approval, I could take the course Introduction to Film Art next semester instead. I realize that this would mean a heavier workload than usual next semester, but I assure you that I would be able to manage my time and keep up.

Thank you for considering my request and I would be happy to come during your office hours and discuss the matter further.

Thank you for your time and effort.

Kind regards,

Beth Torn

Tips

- Start your email by introducing yourself and giving your reason for writing clearly.
- Make it short and clear. Just include the most important information.
- Finish by thanking the person for his/her help and offering to discuss the matter further if necessary.
- Close with a proper ending ("Regards", also "With regards", "Best regards", or "Kind regards").

Part III Task

Assume you are a student studying Film Shooting in an overseas university. Now you have a problem with choosing a topic for your subject essay. Please write a formal email to your professor about this issue in about 150 words.

Students will be able to:

- gain an appreciation of Zhang Huoding's works;
- describe Zhang Huoding's experience as a Peking Opera artist;
- understand the vocabulary of drama and theater;
- gain an appreciation of Maugham's works;
- learn how to write an advertisement.

Unit 6

The Pursuit of Art

Life

Lead-In

Task 1 Exploring the Theme

Passage I

1. Try to decide whether the following statements are true or false according to what you have heard.

() 1) Some critics attribute the purity of Maugham's style to the fact that French is his first language.

() 2) Maugham took to writing later because he was not qualified for a physician.

() 3) Although he wrote a lot of novels and plays, Maugham used to lead a very poor life for a long time.

() 4) Maugham was gaining increasing popularity because his writing style was trendy in the context of experimental modernist literature.

() 5) The characters in some of Maugham's works are often based upon those whom he had known or whose lives he had somehow been familiar with.

2. Listen to the recording again. Fill in the blanks in the following paragraph according to what you have heard.

Maugham's novels are written in a style revealing the qualities of 1) _____, 2) _____, and harmony which the author sought to attain. Content to narrate an interesting story from his 3) _____ angle of vision, he brought to the style a gift for creating interesting characters who reflect life's 4) _____. In his later works, Maugham's 5) _____ persona is a character interested in people, yet detached in his analysis of their actions and 6) _____. The narrator demonstrates an unusual degree of tolerance for human mistakes and contradictions and is 7) _____ to judge the actions of human beings. He writes primarily of adults in 8) _____ with one another and with social mores. Frequently, his characters grow in tolerance and 9) _____ of human life, which is 10) _____ somewhat pessimistically.

Passage II

You will hear a passage. At the end of the passage, you will hear four questions. Both the passage and the questions will be spoken only once. After you hear a question, you must choose the best answer from the four choices marked A, B, C, and D.

1) Huangmei Opera originated from _____.

 A. Anqing, Anhui Province B. Jiujiang, Jiangxi Province

 C. Wuhu, Anhui Province D. Huangmei, Hubei Province

2) Which of the following statements is NOT true about Huangmei Opera?

 A. Huangmei Opera was originally a combination of local folk songs, dances and ancient operas.

B. Huangmei Opera is easy to understand and learn.

C. Wu Qiong describes Huangmei Opera as "country music" among traditional Chinese operas.

D. Huangmei Opera doesn't have many star performers and its origin is unclear.

3) Wu Qiong and four other young actresses were dubbed the "best five" of Huangmei Opera in China in _____.

 A. 1975 B. 1992 C. 1980 D. 2003

4) Wu Qiong won a stable fan base in the 1990s by _____.

 A. singing pop songs and playing roles on TV

 B. performing Huangmei Opera shows

 C. performing Beijing Opera shows

 D. teaching Huangmei Opera at the provincial arts school

Task 2 Brainstorming

Answer the following questions.

1) How much do you know about the Britain's great writer, W. Somerset Maugham?

2) How much do you know about other traditional Chinese opera artists?

Task 3 Building Vocabulary

Discuss with your classmates, and try to describe the following word and phrases in English.

Huangmei Opera	fan base	the "best five" of Huangmei Opera
transmigration	the craving for immortality	

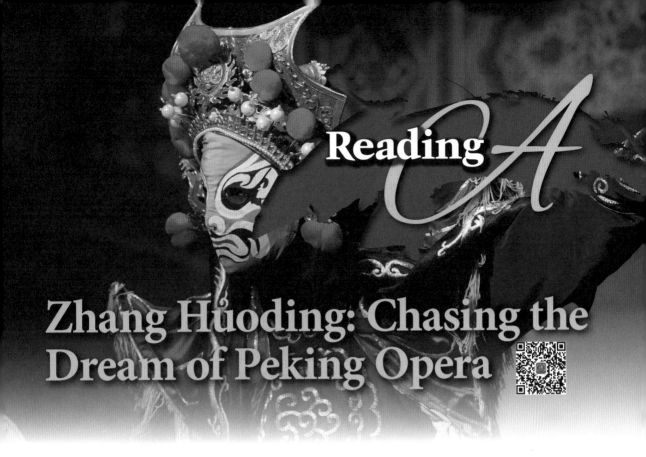

Reading A

Zhang Huoding: Chasing the Dream of Peking Opera

1 On September 2, 2015, Peking Opera artist Zhang Huoding visited the Lincoln Center for the Performing Arts[1] in New York for the first stop of her first world tour. She performed *Legend of the White Snake*[2] and *The Jewelry Purse*[3], two classical Peking Opera plays, for American audience. "She's got this special **evocative** quality onstage—grace and charm that seems to enchant the audience," said David Wang, a Harvard literature scholar who has kept a close eye on Zhang's career for long. "But she also has this tremendous vocal capacity that renders in a kind of low-key, **melancholy** way." *Legend of the White Snake* tells the story of love between a man named Xu Xian and a white snake maiden called Bai Suzhen. Their love is **thwarted** by Buddhist monk Fahai. *The Jewelry Purse* tells the story of a kind-hearted wealthy lady who escapes a desperate situation, with the help from a woman she had

evocative *adj.* 令人回味的

melancholy *adj.* 忧郁的

thwart *v.* 阻挠

1　林肯艺术中心，全世界最大的艺术会场，纽约古典音乐界的中心，纽约文化中心。

2　《白蛇传》。1950 年，田汉曾将传统神话剧《白蛇传》改编为 25 场京剧《金钵记》；1953 年再度修改剧本，恢复原剧名《白蛇传》。

3　《锁麟囊》，又名《牡丹劫》，是著名剧作家翁偶虹在 1937 年应程砚秋之约而作。

don *v.* 披上；穿上；戴上
tactful *adj.* 得体的
immerse *v.* 沉浸

satiate *v.* 使饱享；满足

previously helped. During the performance, Zhang Huoding **donned** different costumes and made multiple stunning appearances to deliver pure, remote, **tactful**, and low-pitched singing that **immersed** the audience into the play to laugh and shed tears for the characters. After the curtain dropped, Zhang was pushed back to the stage by several curtain calls, but her bowing did little to **satiate** the audience's thirst for more performance.

2 Before visiting the United States, Zhang Huoding had already become a well-known Peking Opera star in China for a long time. However, in 1986, at the age of 15, she was nearly rejected by a school specializing in Chinese theater art. A saying goes that "every minute on stage requires 10 years of offstage practice." Behind her eventual success was the unimaginable dedication.

3 Zhang Huoding was born in 1971 in Baicheng City, northeastern China's Jilin Province. Her brother was admitted to a local Chinese theater art school at the age of 11. Influenced by her brother, she also developed a strong interest in Chinese theater art. She was firmly supported by her parents. At the age of nine, Zhang signed up for the admission examination

of the local opera school. However, Zhang failed to pass the exam several times over the following years. She once joked that her experience with the test was like Fan Jin who was a fictional character in anchient China. He first took the imperial examination at the age of 20 and didn't pass it until he was 54 years old. Even over the age limit of primary school, she continued to apply to Chinese theater art schools across the country every year.

4 Zhang's **perseverance** was driven by her passion for Peking Opera. "It is amazing," she beamed. "I felt my life would be meaningless if I couldn't perform it."

perseverance *n.* 毅力；韧性

5 Seeking to end his daughter's worries about her future, Zhang's father wrote a letter to the principal of Tianjin Art Vocational School. "The letter was very long, and he requested the principal to see me, then either accepting me or **explicitly** declaring that I was unfit to study traditional opera," she **recounted**.

explicitly *adv.* 明确地；明白地

recount *v.* 讲述；叙述（亲身经历）

6 Zhang Huoding was eventually admitted to Tianjin Art Vocational School as the only student not admitted under unified enrollment. In 1986, her annual tuition was 560 yuan. At the time, the amount was about a half-year income of an ordinary family. To cover the tuition, Zhang's parents made extraordinary efforts to save money. "I promised my parents I would practice hard." Zhang understood the difficulties she caused her parents.

7 Learning Chinese theater requires practice from childhood, and many performers start at a very early age. Zhang Huoding was already 15 years old when she was finally enrolled in the school, an age usually considered too late. But Zhang persisted with hard work. Because no teacher was willing to help her, she had to listen to tapes extensively on her own. Dessite lack of proper curriculum, she **looked in on** lessons from other classes. Zhang's efforts were noticed by the famous Peking Opera artist Meng Xianrong[1]. Meng was so moved by Zhang's **endeavor** that

look in on 短暂拜访

endeavor *n.* 努力

1 孟宪荣，被誉为"天津旦角之母"，曾向程砚秋先生的女婿陶汉祥学习程派。

mentor *n.* 导师

he offered to be her **mentor**.

8　During Zhang's three years at Tianjin Art Vocational School, she learned 30 plays, equal to the volume a normal student can memorize in seven years. After graduation, Zhang was recruited by a Peking Opera troupe in Beijing. Her unique voice attracted Zhao Rongchen[1], a famous master in the Cheng School[2] of Peking Opera.

protégé *n.* 门徒；门生

9　Zhao was an outstanding **protégé** of Cheng Yanqiu[3], the founder of the Cheng School. Nearly 80 years old at that time, he was not seeking protégés of his own anymore, but offered to mentor 23-year-old Zhang Huoding as his last one. Learning from Peking Opera master empowered Zhang to make rapid progress in understanding the depths of the art. "I learned a lot of fundamental skills from Mr. Zhao," she said. "I often spend a whole morning just trying to sing one word right. Sometimes it takes three days to practice some minute details. Mr. Zhao changed my life."

essence *n.* 本质；实质；精髓

10　"Zhang Huoding's performances started capturing the **essence** of the Cheng School," commented Peking Opera artist Ye Shaolan[4]. "She performs in styles both of the Cheng School and her own, so the audience can hear and see both characteristics in the roles she makes. She manages to make stylized art more rational. Zhang injects her own quality of **gentility** and elegance into the art of the Cheng School. She never makes **deliberate** moves to win applause but instead she inspires warm applause naturally. This is the highest state of the art."

gentility *n.* 文雅；彬彬有礼；高贵的身份

deliberate *adj.* 故意的；蓄意的

massive *adj.* 大量的；巨大的

11　In 2019, Zhang Huoding's *Farewell My Concubine*[5] became a **massive** hit in Beijing and Shanghai. She had made painstaking

1　赵荣琛，京剧表演艺术家。1946 年在上海正式向程砚秋行拜师礼。

2　程派，京剧旦角四大流派之一，由程砚秋先生创立，其最显著的特点是刚柔相济、柔中有刚。

3　程砚秋，杰出的表演艺术家、戏剧理论家、教育家，京剧四大名旦之一。

4　叶少兰，京剧艺术家叶盛兰之子，著名京剧表演艺术家，国家一级演员，首届梅花奖获得者，中国现当代最杰出的京剧表演艺术大师之一。

5　《霸王别姬》，京剧艺术大师梅兰芳表演的梅派经典名剧之一。《霸王别姬》的唱腔整理由京剧演奏家和作曲家万瑞兴完成。

preparations for the play for 10 years. Tickets sold out soon. Fans and professionals from all over the country rushed to catch a **glimpse** of the different image of Yu Ji that she presented in the play.

glimpse *n.* 一瞥；短暂的感受

12 The **epic** battle between Chu and Han armies after the Qin Dynasty (221–207 B.C.) was overthrown is well-known in China. Legends about the war **abound**. When Lord Xiang Yu of Chu was defeated, he bid farewell to his beloved concubine Yu Ji. Yu Ji chanted poems while performing a sword dance as a farewell, which was reported as beautiful and tragic.

epic *adj.* 史诗般的

abound *v.* 大量存在；有许多

13 Performing *Farewell My Concubine* had been Zhang Huoding's dream for many years. After 10 years of hard work, she finally brought the play to the stage. The road to achieve the dream was not smooth. It took her 10 years of hard work to turn the dream into reality. Across the decade, the music has changed from time to time. Wan Ruixing, who has worked with Zhang for a long time, cooperated with her on this play. When Wan fell ill and was admitted to the hospital several times, the work had to be suspended. During the 10 years, Zhang Huoding became a teacher and a mother. She takes on new roles in life while continuing to pursue her dream. Only persistence can make dreams come true.

14 Perseverance helps her realize the dream of becoming a Chinese theater art performer. Now she is realizing another dream of giving the character of Yu Ji her **singular tenacity**.

singular *adj.* 非凡的；突出的

tenacity *n.* 坚韧；坚毅

(1191 words)

(From China Pictorial website.)

Part I　Understanding the Text

Task 1　Global Understanding

1. Read the text and decide whether the following sentences are true (T) or false (F).

(　　) 1) The text is mainly about the first world tour performances of Peking Opera artist Zhang Huoding in 2015.

(　　) 2) Zhang Huoding failed her first dream and now she is realizing another dream of giving the character of Yu Ji her own style.

(　　) 3) Zhang Huoding's passion for Peking Opera gave her strong determination to become a Peking Opera performer.

(　　) 4) Zhang Huoding has never been accepted by any Chinese theater art school in the country, however, learning from a Peking Opera master empowered Zhang to make rapid progress, and finally become a successful Peking Opera artist.

(　　) 5) It took Zhang Huoding 10 years' hard work to turn the dream of performing *Farewell My Concubine* into reality. She finally brought the play to the stage and made it a massive hit in Beijing and Shanghai.

2. Fill in each of the blanks on the left column with the correct paragraph number to match the corresponding main idea of each paragraph on the right column.

Paragraphs	Main Ideas
	After 10 years of hard work, Zhang Huoding put *Farewell My Concubine* on the stage and realized her dream of giving the character of Yu Ji her own style of tenacity.
	Zhang Huoding's hard work in the art school and enthusiasm for Peking Opera performance was noticed by a famous Peking Opera artist and offered to be her mentor.
	Influenced by her brother, Zhang Huoding developed a strong interest in Chinese theater art. At the age of 9 she began to apply to Chinese theater art schools across the country every year.

Paragraphs	Main Ideas
	In 2015, Peking Opera artist Zhang Huoding performed two classic Peking Opera plays for American audiences during her first world tour in Lincoln Center for the Performing Arts in New York and achieved great success.
	Peking Opera artist Ye Shaolan highly commented on Zhang Huoding's performing art. Ye believes that Zhang Huoding integrates her own quality of gentility and elegance to the art of the Cheng School.

Task 2 Detailed Understanding

1. Read the text again and choose the best answer to each question below.

1) Which of the following statements is true?

 A. *Legend of the White Snake* tells the romantic story of love between a man named Xu Xian and a white snake maiden called Bai Suzhen.

 B. *The Jewelry Purse* tells the story of a kind-hearted wealthy woman who escapes a desperate situation thanks for the help from a Buddhist monk Fahai she had previously helped.

 C. In the play *Farewell My Concubine*, when Lord Xiang Yu of Chu was defeated, he killed his beloved concubine Yu Ji.

 D. *Farewell My Concubine* is a story about a fictional character who first took the imperial examination at age 20 and didn't pass until 54 years old.

2) According to the text, Peking Opera artist Zhang Huoding _____.

 A. was admitted to a local Chinese theater art school at the age of 11

 B. continued to apply to Chinese theater art schools across the country every year though her parents didn't support her

 C. was already 15 years old when she was finally enrolled in an art school, a proper age of learning Peking Opera

 D. made rapid progress in understanding the depths of the art learning from a famous master in the Cheng School of Peking Opera

3) According to the text, which one of the following is true?

 A. Zhang Huoding's performances started capturing the essence of the Mei School of Peking Opera.

 B. Performing *Legend of the White Snake* had been Zhang Huoding's dream for many years.

 C. After 10 years of hard work, Zhang Huoding's *Farewell My Concubine* became a massive hit in Beijing and Shanghai.

 D. Zhang Huoding finally brought the play *Farewell My Concubine* to the stage of Lincoln Center for the Performing Arts in New York during her first world tour.

2. Answer the following questions according to the text.

1) What are Zhang Huoding's dreams mentioned in the text? How did she realize her dreams?

2) What is the "highest state of the art" mentioned in Paragraph 10?

3) How do you understand "giving the character of Yu Ji her singular tenacity" in the last paragraph?

Part II　Building Language

Task 1　Key Terms

The following words or phrases are related to theater. Discuss with your classmates and provide your understanding about each term in English.

1) don: _____

2) tactful: _____

3) explicitly: _____

4) look in on: _____

5) mentor: _____

6) protégé: _____

7) gentility: _____

8) epic: _____

Task 2　Vocabulary

Replace the underlined parts in the following sentences with the expressions below that best keep the original meaning.

massive	glimpse	perseverance	thwarted	singular
recounted	deliberate	immersed	satiate	abounds

1) Her failing eyesight <u>held back</u> her ambition to become an artist.

2) The young girl <u>dipped</u> the fabric completely in the dye.

3) The festival offers enough choice to <u>satisfy</u> most appetites.

4) Stories about hard times teach the value of <u>determination</u> and hard work.

5) He then <u>told</u> the story of the interview for his first job.

6) Witnesses say the firing was <u>obviously planned</u> and sustained.

7) We know that little changes can make a <u>great</u> difference.

8) Will tonight give us the first <u>look</u> of a future superstar?

9) The writing of history <u>is plentiful</u> with arguments about what happened and why.

10) Enya's music possesses a <u>remarkable</u> sense of vision and originality.

Part III Translation

1. Translate the following sentences into Chinese.

1) During the performance, Zhang Huoding donned different costumes and made multiple stunning appearances to deliver pure, remote, tactful, and low-pitched singing that immersed the audience into the play to laugh and shed tears for the characters.

2) A saying goes that "every minute on stage requires 10 years of offstage practice." Behind her eventual success was the unimaginable dedication.

3) Zhang injects her own quality of gentility and elegance into the art of the Cheng School. She never makes deliberate moves to win applause but instead she inspires warm applause naturally. This is the highest state of art.

4) In 2019, Zhang Huoding's *Farewell My Concubine* became a massive hit in Beijing and Shanghai. She had made painstaking preparations for the play for 10 years. Tickets sold out soon. Fans and professionals from all over the country rushed to catch a glimpse of the different image of Yu Ji that she presented in the play.

5) Perseverance helps her realize the dream of becoming a Chinese theater art performer. Now she is realizing another dream of giving the character of Yu Ji her singular tenacity.

2. Translate the following sentences into English.

1) 张火丁以其娴熟的唱功，在京剧旦角行当中形成了具有独特魅力的"程腔张韵"风格。

2) 程砚秋在表演中非常注重情感表达，并因其对于女性悲剧命运的呈现而广为人知。

3) 《白蛇传》源于一个古老的传说故事，故事中白蛇化身为一个美丽的女子，并与凡人结为夫妇。

4) 《锁麟囊》由剧作家翁偶虹与"四大名旦"之一的程砚秋共同创作。 评论家们认为它展示了"程派的精髓"。

5) 《霸王别姬》讲述了西楚霸王项羽与妃子虞姬之间的爱情故事，是京剧最著名的剧目之一。

Reading B

Spiritual Pursuit[1]

reverie *n.* 幻想；沉思

fret *v.* 使烦恼

make amends 弥补

loquacious *adj.* 话多的

disposed *adj.* 有……倾向的

garrulity *n.* 多嘴

on sufferance 出于容忍；出于宽容

warily *adv.* 谨慎地；留心地

1　My **reveries** tend often to be concerned with my long past youth. I have done various things I regret, but I make an effort not to let them **fret** me; I say to myself that it is not I who did them, but the different I that I was then. I injured some, but since I could not repair the injuries I had done I have tried to **make amends** by benefiting others. Most people talk too much and old age is **loquacious**. Though I have always been more **disposed** to listen than to talk, it has seemed to me of late that I was falling into the defect of **garrulity**, and I no sooner noticed it than I took care to correct it. For the old man is **on sufferance** and he must walk **warily**.

1　本文作者为 William Somerset Maugham。威廉·萨默塞特·毛姆（1874–1965），英国著名小说家、剧作家。代表作有小说《月亮与六便士》(*The Moon and Sixpence*)、《人生的枷锁》(*Of Human Bondage*)、《刀锋》(*The Razor's Edge*)，戏剧《圈子》(*The Circle*)、《一个体面的男人》(*A Man of Honor*) 和《比我们高贵的人》(*Our Betters*) 等。1920 年毛姆来到中国，写了游记《在中国的屏风上》(*On a Chinese Screen*)，并以中国为背景写了一部长篇小说《面纱》(*The Painted Veil*)。1954 年，英国女王授予其"荣誉侍从"的称号，他成为皇家文学会的会员。

2 And what of the soul? The **Hindus** call it the Atman[1], and they think it has existed from **eternity** and will continue to exist to eternity. It is easier to believe that than that it is created with the conception or birth of the individual. They think it is of the nature of Absolute Reality[2], and having **emanated** from that will at long last return to it. It is a pleasing fancy; no one can know that it is anything more. It entails the belief in **transmigration**, which in turn offers the only **plausible** explanation for the existence of evil that human **ingenuity** has conceived, for it supposes that evil is the **retribution** for past error. It does not explain why an all-wise and all-good creator should have been willing or even able to produce error.

3 But what is the soul? From Plato[3] onwards many answers have been given to this question, and most of them are but modifications of his **conjectures**. We use the word constantly, and it must be presumed that we mean something by it. Christianity has accepted it as an article of faith that the soul is a simple spiritual substance created by God and immortal. One may not believe that and yet attach some signification to the word. When I ask myself what I mean by it I can only answer that I mean by it my consciousness of myself, the I in me, the personality which is me; and that personality **is compounded of** my thoughts, my feelings, my experiences and the accidents of my body. I think many people shrink from the notion that the accidents of the body can have an effect on the constitution of the soul. There is nothing of which for my own part I am more assured. My soul would have been quite different if I had not **stammered** or if I had been four or five inches taller; I am slightly **prognathous**; in my childhood they did not know that this could be remedied by a gold band worn while the jaw is

Hindus *n.* 印度教徒

eternity *n.* 来世；不朽

emanate *v.* 产生

transmigration *n.* 轮回

plausible *adj.* 貌似有理的；可靠的

ingenuity *n.* 聪明才智；独创性

retribution *n.* 报应；惩罚

conjecture *n.* 推测；猜想

be compounded of 由……组成的

stammer *v.* 口吃；结结巴巴地说

prognathous *adj.* 下巴突出的

1 来自古印度梵文，灵魂的意思。可以指称个别的灵魂体，也可以是众多的、集合体的灵魂体组合。也有人将此观念用以形容世界灵魂、宇宙灵魂，类似心理学里"集体潜意识"的说法。

2 实有（佛教术语），实在的有。

3 柏拉图（公元前 427—前 347），古希腊伟大的哲学家，也是整个西方文化中最伟大的哲学家和思想家之一。他的老师是苏格拉底，学生是亚里士多德，三人并称为希腊三贤。

malleable *adj.* 可塑的；可锻的

countenance *n.* 面容

dental *adj.* 牙科的

apparatus *n.* 设备；器具

still **malleable**; if they had, my **countenance** would have borne a different cast, the reaction toward me of my fellows would have been different and therefore my disposition, my attitude to them, would have been different too. But what sort of thing is this soul that can be modified by a **dental apparatus**? We all know how greatly changed our lives would have been if we had not by what seems mere chance met such and such a person or if we had not been at a particular moment at a particular place; and so our character, and so our soul, would have been other than they are.

conglomeration *n.* 聚集（物）

idiosyncrasy *n.* （个人独有的）气质；性格

manifestation *n.* 表示；显示

magnanimous *adj.* 宽宏大量的

contrariwise *adv.* 反之；相反

penury *n.* 贫困；贫穷

querulous *adj.* 易怒的；抱怨的

malevolent *adj.* 恶意的；居心不良的

contingent on 取决于

4 For whether the soul is a **conglomeration** of qualities, affections, **idiosyncrasies**, I know not what, or a simple spiritual substance, character is its sensible **manifestation**. I suppose everyone would agree that suffering, mental or physical, has its effect on the character. I have known men who when poor and unrecognized were envious, harsh and mean, but on achieving success became kindly and **magnanimous**. Is it not strange that a bit of money in the bank and a taste of fame should give them greatness of soul? **Contrariwise** I have known men who were decent and honourable, in illness or **penury** become lying, deceitful, **querulous** and **malevolent**. I find it then impossible to believe that the soul thus **contingent on** the accidents of the body can exist in separation from it. When you see the dead it can hardly fail to occur to you that they do look awfully dead.

5 I have been asked on occasion whether I would like to live my life over again. On the whole it has been a pretty good life, perhaps better than most people's, but I should see no point in repeating it. It would be as idle as to read again a detective story that you have read before. But supposing there were

such a thing as **reincarnation**, belief in which is explicitly held by three quarters of the human race, and one could choose whether or not one would enter upon a new life on earth, I have in the past sometimes thought that I should be willing to try the experiment on the chance that I might enjoy experiences which circumstances and my own idiosyncrasies, spiritual and **corporeal**, have prevented me from enjoying, and learn the many things that I have not had the time or the occasion to learn. But now I should refuse. I have had enough. I neither believe in immortality nor desire it. I should like to die quickly and painlessly, and I am content to be assured that with my last breath, my soul, with its aspirations and its weaknesses, will **dissolve into** nothingness. I have taken to heart what Epicurus[1] wrote to Menoeceus[2]: "Become accustomed to the belief that death is nothing to us. For all good and evil consists in sensation, but death is deprivation of sensation. And therefore a right understanding that death is nothing to us makes the mortality of life enjoyable, not because it adds to it an infinite span of time, but because it takes away the craving for immortality. For there is nothing terrible in life for the man who has truly comprehended that there is nothing terrible in not living."

(1032 words)

(From: Maugham W. S. *A Writer's Notebook*. London: Vintage Classics, 2010.)

reincarnation *n.* 再生；化身

corporeal *adj.* 肉体的；物质的

dissolve into （使）熔化成

1　伊比鸠鲁（公元前 341—前 270），古希腊哲学家、无神论者（被认为是西方第一个无神论哲学家），伊比鸠鲁学派的创始人。他的学说的主要要旨就是人要达到不受干扰的宁静状态，并学会快乐。

2　米诺修斯，伊比鸠鲁的挚友。

Part I Understanding the Text

Task 1 Global Understanding

1. Read the text and identify the main ideas.

1) How do you understand the sentence "What is the soul"?

2) Talk with your classmates and discuss about the relationship between spiritual and corporeal existence.

2. Write down the main ideas of each paragraph.

Paragraph 3: _____

Paragraph 4: _____

Paragraph 5: _____

Task 2 Detailed Understanding

1. Answer the following questions according to the text.

1) How do you understand the sentence "Evil is the retribution of past error."?

2) Do you agree that suffering, mental or physical, has its effect on the character? Why or why not?

3) Why does the author say "I neither believe in immortality nor desire it"?

2. Discuss the following questions with your partner.

1) How do you understand "Absolute Reality" in Paragraph 2?

2) What is the "reincarnation" mentioned in Paragraph 5?

3 What were Maugham's attitudes when he was asked on occasion whether he would like to live his life over again?

Part II Building Language

Task 1 Key Terms

Discuss with your classmates and provide your understanding about each term in English.

1) soul: _____

2) mortality: _____

3) corporeal: _____

4) loquacious: _____

5) affection: _____

6) modification: _____

7) ingenuity: _____

8) Christianity: _____

9) spiritual: _____

10) sensation: _____

Task 2 Vocabulary

Choose the correct word or phrase from the box below to complete each of the following sentences. Change the form where necessary.

fret	stammer	conglomeration	reverie	plausible
spiritual	sensation	countenance	transmigration	eternity
contrariwise	comprehend	manifestation	on the whole	be concerned with

1) The worst part was definitely the baritone's singing. That was just one horrible _____ of music genres.

2) High-quality dramas can enrich your _____ life.

3) _____, however, even these laudatory critics showed themselves to be uninterested in the stories that this neorealist theater told.

4) The young actor started to _____ as soon as he got on stage.

5) Watching a street play not only brings you comfort and elegant feel, at the same time gives unlimited romantic _____.

6) The original musical *Jews in Shanghai* has created a great _____ when it premiered in 2015.

7) Colin Firth is Elizabeth II's father in the movie *The King's Speech*, a reluctant king who courageously overcame his _____.

8) During the rehearsal, the director emphasized that every actor should _____ his character's inner thoughts.

9) _____, it is true that every time you create a new role on stage—even more, a new accomplishment—you increase your power of life.

10) A serious critic must _____ the content, unique structure, and special meaning of a modern play.

11) The well-known musical actress told the news conference that "My performance is a(n) _____ of this philosophy."

12) They believed that their souls would be condemned to burn in hell for _____.

13) Many people still believe in the _____ of souls after death.

14) "It surely seems _____ that happy and confident actors would be more creative and explosive." said the veteran actor.

15) When the curtain fell, an expression of indescribable happiness shone in the ensemble's _____, even though tears were rolling down their cheeks.

Part III Translation

1. Translate the following sentences into Chinese.

1) Though I have always been more disposed to listen than to talk, it has seemed to me of late that I was falling into the defect of garrulity and I no sooner noticed it than I took care to correct it.

2) And what of the soul? The Hindus call it the Atman, and they think it has existed from eternity and will continue to exist to eternity. It is easier to believe that than that it is created with the conception or birth of the individual.

3) I think many people shrink from the notion that the accidents of the body can have an effect on the constitution of the soul. There is nothing of which for my own part I am more assured.

4) Contrariwise I have known men who were decent and honorable, in illness or penury become lying, deceitful, querulous and malevolent. I find it then impossible to believe that the soul thus contingent on the accidents of the body can exist in separation from it.

5) And therefore a right understanding that death is nothing to us makes the mortality of life enjoyable, not because it adds to it an infinite span of time, but because it takes away the craving for immortality. For there is nothing terrible in life for the man who has truly comprehended that there is nothing terrible in not living.

2. Translate the following sentences into English.

1) 毛姆十岁失去父母双亲后，搬到了英国，就读于国王学校，在那里因口吃和身材矮小而受人讥笑。

2) 早年在法国的生活对毛姆的文学品味和风格产生了巨大的影响。

3) 毛姆的作品曾被认为是腐朽资本主义社会的代表产物，但现在它们已逐渐为中国读者所熟悉。许多卓有成就的翻译家都曾致力于翻译这些作品。

4) 西方文化受基督教的影响，认为罪人只有通过死亡才能获得永生的希望。

5) 孔子在回答学生就死亡而提出的问题时说："不知生，焉知死？"这个答案反映出孔子对待生这个问题的现实态度，这种态度也是我们国民思想的特点。中国文化更注重"生"，很少思考逃避世俗生活、寻找来世的意义。

Writing Skills

Writing an Advertisement

Part I · Preparation

Task 1 · Introduction

An advertisement is an announcement online, in a newspaper, on television, or a poster about something such as a product, event, or job. It is a kind of public notice asking for or offering services or buying and selling property, goods, etc., or providing information about missing persons, pets, etc.

Task 2 · Preparation Task

The following is an example of an advert. Fill in the blanks with the appropriate words given in the box.

> in half reached sale bring bought maintained sell

Offer to sell

June 10, 2021

Dear Schoolmates, a used bike is on 1) _____ now! I'm a senior student who is about to graduate and leave the campus 2) _____ two weeks. So I've decided not to 3) _____ my bike with me when I leave and I'd like to 4) _____ it to someone who might need it.

It is 5) _____ new, blue and light. Though used, it's still well 6) _____ and in good condition with a suitable seat and strong tires. The bike was 7) _____ two years ago for 628 yuan, and it is now sold at only 328 yuan.

If you are interested in it, please feel free to contact me. I can be 8) _____ at phone 1234567.

Part II Reading Examples

Example 1

Welcome to Starry Night Drama Club

Welcome to Starry Night Drama Club! We are looking for enthusiastic drama lovers to join us.

Starry Night Drama Club was established four years ago. In the club you can enjoy a variety of activities including staging musical dramas, holding group discussions on theatre and watching plays. You will have a lot of opportunities to take part in these extra-curricular activities. Your active participation is also helpful to your communication skills. And through various activities, you could develop your appreciative and critical thinking abilities in drama.

If you are interested in joining our club please contact us at 123456 or on Starry Night Drama Club @ 123.com. The deadline for entries is Oct. 1st.

Example 2

A Flier of Selling DIY Postcards

As the new year is coming, we are going to sell our DIY postcards from 1:30 to 5:00 p.m. on Dec 20 at the square outside the canteen as part of the annual flea market organized by the Student Union.

All the postcards for sale are made by the students from the Department of Stage Design. Each of them is unique with an exquisite pattern and creative design.

Come to visit us at the flea market, and you may find some postcards that you can buy three and get one free!

Tips

- The opening statement needs to be clear and catch attention.
- Don't bore your readers with long sentences. Be direct and to the point by employing different sentence structures within your ad to keep your readers interested.
- The closing statement should call your readers to action. It should be written creatively enough so that the readers will be curious.
- Include exact dates, locations, and contact channels if necessary.

Part III Task

Suppose you are working for the Theatrical Troupe of your university. Write an audition advert looking for the performers of the play *Hamlet*. You should write at least 120 words but no more than 180 words.

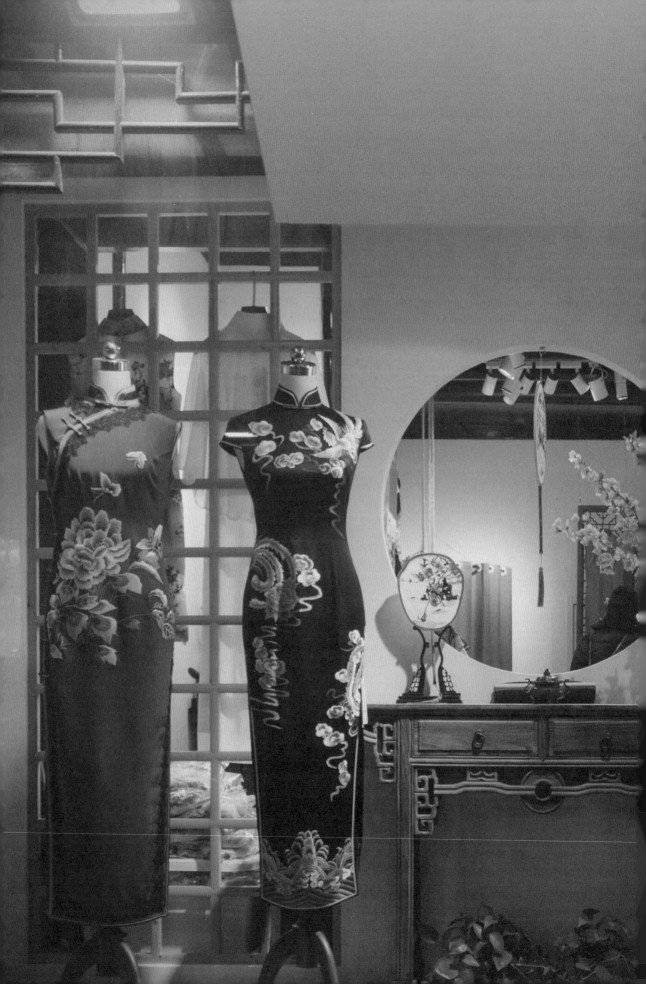

Learning Objectives

Students will be able to:

- ✓ understand the vocabulary of fashion and costume;
- ✓ describe fashion brands and costume traditions;
- ✓ gain an insight into fashion and tradition;
- ✓ write a letter of complaint.

Unit **7**

Fashion and

Costume

Lead-In

Task 1 Exploring the Theme

Listen to a passage and fill in the blanks.

1) Instead of one main fashion look, fashion houses are offering a range of _____.

2) The new prediction for high fashion this year is that "_____" is in.

3) One Italian designer thinks the reason for the confusion of fashion scene this year is a world-wide reaction to the _____ of high fashion over the last ten years.

4) You try to work out your personal style, called "_____".

5) Out of the main fashion centers have come three main looks, the decorative, colorful "boho look", the "_____" streamlined look and the new look, and the "mix and match" look.

Task 2 Brainstorming

Work in pairs and discuss the following questions.

1) What famous Western fashion figures do you know?

2) Do you think wearing Hanfu in China should conform to historical reality, and why?

Task 3 Building Vocabulary

Talk with your classmates, and try to describe the following words and phrases in English.

vogue rags-to-riches innovation Hanfu enthusiast cultural belonging

Reading A

Coco Chanel

1 Gabrielle Bonheur Chanel solidified her reputation with two-piece **ensembles** in wool **jersey**, **cardigan** suits, simple black dresses, and distinctive accessories such as costume jewelry and two-tone shoes. Chanel followed the trend for **diversification** with the 1921 launch of her fragrance Chanel No. 5, created by chemist Ernest Beaux. Chanel No. 5 represented a significant step in the development of designer fragrances, and the eventual financial success of the scent (and other cosmetics) built her fortune. Her **couture clientele** at this time included European royalty, but Chanel was especially favored by actresses, including Gertrude Lawrence[1] and Ina Claire[2]. Chanel maintained a mystique, cultivating an **aloof** persona even with her most famous clients.

2 Early in the decade, Chanel featured pieces with Russian influence including two-piece ensembles with tops based on the roubachka[3], a traditional peasant-style blouse. **Embroidered** Russian **motifs** decorated many pieces. In addition to Russian

ensemble *n.* 全套服装

jersey *n.* 针织套头衫；平针织物

cardigan *n.* （无领）开襟毛衣

diversification *n.* 多样化；变化

couture *n.* 时装；时装设计制作

clientele *n.* （统称）顾客；客户

aloof *adj.* 冷漠；冷淡

embroider *v.* 刺绣

motif *n.* 装饰图案；装饰图形；（文学作品或音乐的）主题；动机

1 格特鲁德·劳伦斯，英国女演员，也是一名舞者、歌手。

2 艾娜·克莱尔，美国女演员，参演电影《屋上的提琴手》。

3 传统的俄罗斯农夫风格长罩衫。

vogue *n.* 流行；时髦

sleek *adj.* 线条流畅的；造型优美的；光滑的；时髦的

embellishment *n.* 装饰（品）；润色

sheath dress *n.* 紧身连衣裙

topstitching *n.* （在衣服等上面）装饰性地加缝一道针迹；上明线

beige *n.* 浅褐色；米黄色

burgundy *n.* 深红色

garçonne *adj.* （法语）假小子的；像男孩子似的

sequined *adj.* （衣服）装饰有闪光小圆片的

cuff *n.* 袖口

inspiration, Chanel also followed the **vogue** for Asian styles.

3　　As the decade continued other influences prevailed and her designs were **sleeker** with simpler **embellishment**. By around 1923, Chanel's work was typified by straight **sheath dresses**, often with **topstitching** or simple self details. These simple looks often featured Chanel's taste for black, **beige**, and other neutrals, but she also used a variety of colors in her collections, favoring shades of red, from **burgundy** to scarlet to pink, especially in eveningwear. She strongly promoted the dress and coat ensemble for smart daywear, which became a signature look for the house. Her spare styles and borrowings from menswear contributed to the development of the **garçonne** look. Her jersey pieces were in such demand that she opened her own mill, Tricots Chanel, in order to meet the need. A woven fabric mill, Tissus Chanel, was also opened.

4　　Also fundamental to the Chanel look was the black dress, produced in many variations, including jersey sport versions, woven fabrics for day, and beaded and **sequined** sleeveless styles for eveningwear. The concept of the "little black dress", which became associated with Chanel, had many precedents. In 1922, a designer of the house of Premet, known for very modern clothes, designed a simple black dress, "La Garçonne", that featured a white collar and **cuffs** like a maid's uniform. The dress was widely imitated, and a likely inspiration for Chanel's black dresses.

5　　The reputation of Coco Chanel has magnified in the years since her death in 1971, establishing her in the public consciousness as perhaps the most influential designer of the 20th century. While many of the styles associated with Chanel are part of the contemporary wardrobe, her innovations have become overstated as inventions, with claims that include "Chanel invented jersey", "Chanel invented black dresses", "Chanel invented costume jewelry"—even "Chanel invented modern clothing".

6　　She was not the most famous designer of her day, sharing

the spotlight with Lanvin[1], Lelong[2], Patou[3], and Vionnet[4], and her designs built on the work of other designers. But Chanel's continuing appeal owes much to her **rags-to-riches** life story. The social-climbing **couturiere** often **obscured** her humble origins, a fact that has frustrated **biographers** and added to the Chanel **mystique**. Sent to an orphanage at the age of twelve by her widowed father, she was educated by nuns. At seventeen, she attended a **convent** school. Afterward, she worked as an assistant in a shop that sold **lingerie**, and sang in a cafe frequented by army officers. At this time, she met Etienne Balsan[5]; independently wealthy from a family textile fortune, Balsan bred horses on his nearby estate. Chanel went to live with him there in 1907 and the **equestrian** atmosphere and Balsan's social circle were fundamental to her education in the ways of the world. Through Balsan, Coco met her next lover, Capel[6], a British polo player and businessman. Chanel began a **millinery** business, operating out of a Paris apartment. Capel helped her expand into her own millinery shop and then into a clothing store in Deauville[7], and a couture house in Biarritz. With her move to 31 rue Cambon, Paris, in 1919, she was able to operate a fully **fledged maison de couture**.

7 Although she was reported to have spent little time in the workrooms, Chanel had definite ideas about construction; she obsessed over details and demanded endless fittings. Although taught to sew by the nuns at the orphanage, she had no genuine training in couture and this often caused disagreements with her skilled workers, whose knowledge of garment construction **exceeded** her own.

rags-to-riches *adj.* 从贫穷到富裕的；白手起家的

couturiere *n.* 设计女装的女设计师；女式时装店女店主

obscure *v.* 使模糊；使隐晦

biographer *n.* 传记作者

mystique *n.* 秘诀；奥秘

convent *n.* 女修道院

lingerie *n.* 女内衣

equestrian *adj.* 马术的

millinery *n.* 女帽业；（商店的）帽类

fledged *adj.* 能飞翔的；羽翼已丰的

maison de couture *n.* （法语）女子时装店

exceed *v.* 超过

1　朗万，著名设计师，她的设计生涯长达 50 多年，其设计在不同的时代都具有鲜明的时代特色。

2　勒隆，杰出的高级定制设计师。

3　帕陶，法国设计师，于 1914 年在巴黎创立自己的品牌。

4　维奥内特，由她首创的"斜裁"法至今仍影响着一代又一代的时装设计师。

5　艾迪纳·巴桑，香奈尔的情人。

6　卡佩尔，香奈尔的情人。

7　多维尔，法国城市，以诺曼底最优美的海岸闻名。

deportation *n.* 驱逐出境；放逐

take potshots at 肆意抨击；胡乱射击

8 During the Nazi occupation of Paris, Chanel lived with Hans Günther von Dincklage, a German officer, at the Ritz hotel where she kept a suite, and it was perhaps only her friendship with Winston Churchill that saved her from deportation or imprisonment after the war. The fact is that her personal politics could be troublingly added to Chanel's contradictory, unconventional image. Chanel was also famous for being less than gracious with her colleagues. She took potshots at Poiret[1], famously saying publicly that "designing Scheherazade is easy, a little black dress is difficult". But in her personal life and her career, Coco Chanel exemplified a certain kind of woman who, by her own account, lived the life of the 20th century: decisive, sexually liberated, self-made, and successful.

(859 words)

(Adapted from: Cole D. J. & Deihl N. *The History of Modern Fashion*. London: Laurence King Publishing Ltd., 2015.)

1 保罗·波烈，法国时装设计师，现代时装变革第一人。

Part I — Understanding the Text

Task 1 Global Understanding

1. Read the text and decide whether the following sentences are true (T) or false (F).

() 1) Chanel was famous for a wide range of products including clothing, accessories and cosmetics.

() 2) Chanel kept a close relationship with her couture clientele.

() 3) Chanel took inspiration from menswear and added a little more masculinity to women's wear.

() 4) Chanel grew up in a privileged family, which laid the foundation for her later success.

() 5) Chanel was hailed as one of the most famous designers of her time.

2. Write down the main ideas of each paragraph below.

Paragraph 2: _____

Paragraph 4: _____

Paragraph 6: _____

Task 2 Detailed Understanding

1. Read the text again and choose the best answer to each question below.

1) Which of the following is NOT mentioned as Chanel's featured products?

A. Chanel No. 5.

B. Simple black dresses.

C. Menswear.

D. Costume jewelry.

2) What product did Chanel start her career with?

 A. Fragrance. B. Two-piece ensembles.

 C. Accessories. D. Millinery.

3) The following words best describe Chanel's life except _____.

 A. successful B. highborn

 C. innovative D. decisive

2. Answer the following questions according to the text.

1) What is the meaning of "precedents" in Paragraph 4?

2) According to the text, what may be the inspiration for Chanel's black dresses?

3) How do you understand Chanel's living with a German officer during the Nazi occupation of Paris?

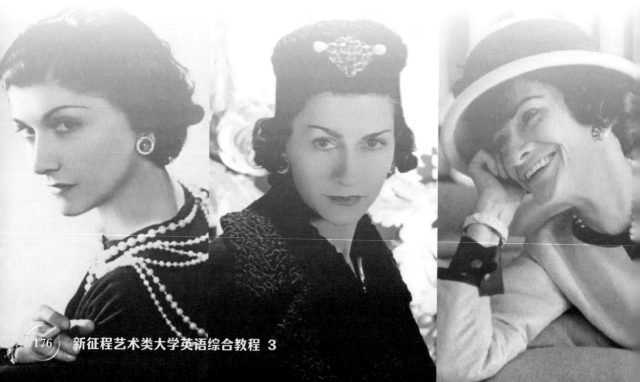

Part II Building Language

Task 1 Key Terms

The following words or phrases are related to fashion. Discuss with your classmates and provide your understanding about each term in English.

1) designer fragrance: _____

2) accessory: _____

3) costume jewelry: _____

4) couture: _____

5) embroidery: _____

6) two-piece ensemble: _____

7) embellishment: _____

8) topstitching: _____

9) sequin: _____

10) maison de couture: _____

11) millinery: _____

12) garment construction: _____

13) fitting: _____

Task 2 Vocabulary

Choose the correct word or phrase from the box below to complete each of the following sentences. Change the form where necessary.

exemplify	suite	owe	magnify	gracious
represent	exceed	neutral	contribute	contemporary
biographer	contradictory	obsess	variation	breed

1) Base colors tend to be greys and blacks and _____ , and most patterns are often modest.

2) Your nurturing abilities rise to the surface and allow you to explore the different _____ of your inner needs.

3) During the conversation between her and her works, the meaning of life has been _____.

4) The most famous names in _____ art are brought together in a collection to which a new work is added each year.

5) The process by which these astonishing changes have occurred _____ as much to accident and experiment as to grand design.

6) _____ are good at discovering little-known facts when they write an account of someone's life.

7) Cloned animals are more likely to die during pregnancy and after birth than those that are _____ naturally.

8) The idea which had _____ me for several weeks seemed to be firmer and clearer.

9) He accepts that he _____ the speed limit last night.

10) The _____ is so exclusive that the hotel does not even advertise it.

11) If a man is _____ and courteous to strangers, it shows that he is a citizen of the world.

12) Earlier this month, she came down with a cold, which quickly developed into pneumonia, which _____ to her death.

13) In an interview with the BBC, the director said he wanted to make a movie that _____ the truth of what went on in Nanjing.

14) The January fashion show, called Future Fashion, _____ how far green design has come.

15) Be aware of "information overload", as too much information can be confusing, _____, and even overwhelming.

Part III Translation

1. Translate the following sentences into Chinese.

1) Chanel No. 5 represented a significant step in the development of designer fragrances, and the eventual financial success of the scent (and other cosmetics) built her fortune.

2) The reputation of Coco Chanel has magnified in the years since her death in 1971, establishing her in the public consciousness as perhaps the most influential designer of the 20th century.

3) Although she was reported to have spent little time in the workrooms, Chanel had definite ideas about construction; she obsessed over details and demanded endless fittings.

4) The fact is that her personal politics could be troublingly added to Chanel's contradictory, unconventional image.

5) But in her personal life and her career, Coco Chanel exemplified a certain kind of woman who, by her own account, lived the life of the 20th century: decisive, sexually liberated, self-made, and successful.

2. Translate the following sentences into English.

1) 香奈儿这个词汇，已经不仅只是代表一个品牌，而是一种风格的树立，她让女人不仅拥有优雅的装束，同时也有了自主的权利。

2) 从设计的前瞻性，到女性思维的解放，香奈儿女士为时尚开创了多项先河。

3) 经典的小黑裙风靡时尚圈近百年，似乎已经成为了香奈儿的灵魂所在，也成了众多女性衣柜里必不可少的单品之一。

4) 毋庸置疑的是，香奈儿5号已经成为现代香水的代名词，乃至成为一个众所皆知的流行文化符号。

5) 香奈儿的商标是由两个背对背交叠的大写字母"C"构成，体现了极致简约的设计理念，同时仿佛又蕴含着无穷的遐想。

Reading B

Something Old, Something New:

Why Young Chinese Are "Sporting" 1,800-year-old Fashion

1　Like teenagers the world over, Chen Bolin, a Chinese university student, feels a need to belong. Unlike many of his peers, Mr. Chen has found a "spiritual home": China of the Wei and Jin dynasties, about 1,800 years ago. So deep is this bond that on special occasions he wears flowing, wide-sleeved robes inspired by third-century dress. One moment of connection stood out, when he wore robes to a museum in Shaoxing, the eastern city where he studies. There he found a sculpture depicting sages from the Wei and Jin era. His own clothes were "exactly like theirs", he recalls happily. He saluted the statues and told them: "Dear ancestors, I've heard so much about you. It is my good fortune to see you today."

sage *n.* 哲人；圣人

2　The teenager developed his passion at high school in Pingliang, perched in the hills of Gansu, an inland province. Though a rather small, sleepy spot, Pingliang is home to a Han culture association. Such clubs are spreading fast. They celebrate the Han ethnic group to which more than nine out of ten people in China belong.

perch *v.* 使坐落于；位于；栖息

revive *v.* （使）苏醒；复活

don *v.* 穿上；戴上；披上

finery *n.* 高雅华丽的衣服；精致的饰物

encompass *v.* 包含；涉及（大量事物）；包围

jangling *adj.* 发出金属撞击声的

bespectacled *adj.* 戴眼镜的

lilac *n.* 淡紫色；丁香紫

barista *n.* 咖啡馆服务员

toga *n.* 托加袍（古罗马市民穿的宽松大袍）

etiquette *n.* （社会或行业中的）礼节；礼仪；规矩

3　"Enthusiasts" claim that a million Chinese, mostly youngsters, regularly wear Hanfu, or robes inspired by traditional Han dress. Some media hail Hanfu as a welcome complement to **revive** traditional culture and values. In April 2018, on the first "Traditional Chinese Garment Day", young Chinese **don** ancient **finery** to demonstrate "cultural confidence" to the world. That **encompasses** not only Han traditions but those of China's 55 official ethnic minorities. At big national events, ethnic-minority delegates typically attend in brightly colored folk costumes trimmed with silks, furs or **jangling** silver jewelry.

4　As Mr. Chen shares his story, the slight, **bespectacled** teenager is wearing robes of **lilac** and white, embroidered with blue clouds, an outfit he says is Jin-dynasty daywear. All around are thousands of fellow enthusiasts attending a Hanfu cultural festival held annually in Xitang, a quaint, canal-side town near Shanghai. Xitang has poetic natural scenery and rich historical and cultural accumulation. These elements are fully in line with people's imagination and expectation of Hanfu culture. Activities held in Xitang Hanfu cultural festival include dynasty carnival, the voice of Hanfu, water T show, Hanfu night, cultural and creative works exhibition, Chinese culture lectures, etc.

5　Hanfu wearers vary in their devotion to historical accuracy. Mr. Chen has brought along a classmate whose look combines a black-and-white military uniform, 21st-century sneakers and an air of faint embarrassment. "I think this is Han dynasty," the classmate mumbles, when asked. The colors are more Ming, says Mr. Chen, gently correcting his friend's dates by about 1,100 years.

6　"Enthusiasm" counts for more than precision. On this sunny festival weekend a local Starbucks boasts **baristas** in **toga**-like robes, a warrior in chain-mail queuing for coffee, and outside, a Taoist priest in a tunic and cloak outfit he calls "a bit of messed-up fusion". Luling Manman, an author invited to the festival as an expert on ancient **etiquette**, defines Hanfu as

"all forms of clothes we Han people have worn over the course of 5,000 years". Others take a narrower view, describing a tradition cut cruelly short when the last ethnic-Han dynasty, the Ming, was overthrown in 1644. In European terms, that is like **wrangling** over a school of fashion that supposedly began in **Neolithic** times and flowered in the Middle Ages, and may or may not have ended during the English civil war[1]. Since the Hanfu movement emerged in the early 2000s, some members have framed it as a way to restore Han customs.

wrangle *v.* （通常为长时间地）争吵；争辩

Neolithic *adj.* 新石器时代的

The Visible Hans

7 At the Xitang festival, it should be said, youngsters wearing Hanfu filled with cultural confidence are not only for its beauty but also for its cultural connotation. Earnest, robe-wearing young men take photographs of each other playing the flute or practicing **archery**. Children take part in a fashion show, **swishing** along a catwalk in long finery.

archery *n.* 射箭术；射箭运动

swish *v.* 刷地（或嗖地、呼地等）移动；（使）快速空中移动

8 The festival organizer is Vincent Fang Wenshan, a **lyricist** behind some of the most famous Mandarin pop songs of recent times. A **dapper** 49-year-old in black embroidered robes, Mr. Fang urges younger "enthusiasts" to be open to modernized Hanfu. He hopes that traditional Chinese customs and modern culture co-exist easily someday, and there should not be a gap of several centuries separating Han traditional culture from the modern world. It is the task of Hanfu fans to bridge that gap.

lyricist *n.* 歌词作者

dapper *adj.* （男人）矮小利落的；衣冠楚楚的

9 Some scholars believe that, in fact, in this era of globalization, "global localization" is the latest trend. Different color collocation and clothing styles highlight the lifestyles and cultural memories of different regions and periods. These simple and ordinary memories are the essence of the traditional Chinese culture. Young people's love for Hanfu is a return to a basic state, namely that every nation should have its own clothes that represent

1 英国内战，是 1642 年 8 月 22 日至 1651 年 9 月 3 日在英国议会派与保皇派之间发生的一系列武装冲突及政治斗争；英国辉格党称之为清教徒革命（Puritan Revolution）。该事件对英国和整个欧洲都产生了巨大的影响。

its own culture. The majestic development and extensive spread of Hanfu culture depend on the efforts of these Chinese youngsters.

quibble *v.* （为小事）争论；吹毛求疵

10 Historians might **quibble** with some details. Plenty of Han traditions actually survived under the Qing. For quite a long time, the Han and Manchu clothes were mixed. People walking on the streets showed up their Ming and Qing clothes at the same time. After the founding of the People's Republic of China, the Zhongshan suit has become an irreplaceable cultural symbol for a long time. Since 2002, the Hanfu movement has emerged on the Internet. Its ultimate goal is to revive the Han national clothing as the starting point to drive the **rejuvenation** of the whole national culture. The clothing culture accumulated by Hanfu for thousands of years has strengthened young people's love for traditional culture and their pride in their own ownership. Hanfu is not only a dress, but a **totem** of identity, a cultural belief, and a sense of belonging that no one can take away.

rejuvenation *n.* 恢复活力

totem *n.* 图腾；图腾形象

(964 words)

(Adapted from: *The Economist*, January 12th 2019.)

Part I Understanding the Text

Task 1 Global Understanding

1. Read the text and decide whether the following sentences are true (T) or false (F).

() 1) Chen Bolin likes to wear the style of Chinese clothes in the Wei and Jin dynasties on special occasions.

() 2) The first "Traditional Chinese Garment Day" was declared in April 2018 to honor the Han nationality.

() 3) All the Hanfu lovers should wear the clothes of their favorite dynasty in the right way.

() 4) There is still disagreement on the definition of Hanfu.

() 5) The organizer of the Xitang festival urges younger "enthusiasts" to be open to modernized Hanfu.

2. Write down the main ideas of each paragraph below.

Paragraph 1: _____

Paragraph 6: _____

Paragraph 8: _____

Task 2 Detailed Understanding

1. Read the text again and choose the best answer to each question below.

1) When did Chen Bolin get interested in Hanfu?

A. When he studied in Shaoxing.

B. When he studied in Pingliang.

C. When he attended a Hanfu cultural festival in Xitang.

D. When he celebrated Traditional Chinese Garment Day.

2) Which of the following words cannot describe youngsters at Xitang festival?

A. Earnest. B. Confident. C. Passionate. D. Constrained.

3) According to Mr. Fang, Hanfu fans are on a mission of _____.

A. wearing Hanfu whenever they can

B. strictly following the standards of ancient Hanfu

C. bridging the gap between Han traditional culture and the modern world

D. joining as many Han culture associations as possible

2. Answer the following questions according to the text.

1) What does Traditional Chinese Garment Day honor?

2) How do you understand "Enthusiasm counts for more than precision" in Paragraph 6?

3) What are the reasons for the popularity of Hanfu nowadays in China?

Part II — Building Language

Task 1 Key Terms

The following words or phrases are related to fashion. Discuss with your classmates and provide your understanding about each term in English.

1) finery: _____

2) military uniform: _____

3) toga: _____

4) chain-mail: _____

5) tunic: _____

6) cloak: _____

7) outfit: _____

8) Zhongshan suit: _____

9) embroidered robe: _____

10) folk costume: _____

Task 2 Vocabulary

Choose the correct word from the box below to complete each of the following sentences. Change the form where necessary.

essence	connotation	accumulation	restore	depict
majestic	quaint	rejuvenation	etiquette	era
trim	complement	perch	swish	highlight

1) The artist is _____ subjective emotions, showing the inner reality as interpreted by the artist rather than the outward form.

2) The hotel is _____ atop a hill overlooking the River Nile in Aswan, Egypt.

3) An alternative or _____ to either of those reforms would be a tax on carbon emissions.

4) At its core, the debate is about how to manage the world's remaining natural ecosystems and about how, and how much, to _____ other habitats.

5) He releases the arrow, and we see the arrow _____ through the air.

6) Beijing Opera, the refined traditional Chinese form of art, is one of the best representatives of the _____ of Chinese culture.

7) It may be _____ to floor length to give ease of movement and a neater appearance, if desired.

8) It is a small, _____ town with narrow streets and traditional half-timbered houses.

9) Netiquette is all about _____ on the Internet.

10) The meaning of children's books lies in conveying the profound _____ behind the story.

11) Overweight is brought from the _____ of surplus fat in the body, as a result of the intake exceeding the consumption of energy.

12) Our study is supposed to be able to respond to the challenges proposed by natural science, humanity and social science of our _____.

13) I just want to recall some of the things we learned so I can _____ them a bit.

14) Every year thousands of tourists flock to China to wander along the _____ Great Wall and gaze in awe at the Forbidden City.

15) Education is the cornerstone of national _____, and equal access to education provides an important underpinning for social equity.

Part III Translation

1. Translate the following sentences into Chinese.

1) Unlike many of his peers, Mr. Chen has found a spiritual home: China of the Wei and Jin dynasties, about 1,800 years ago.

2) In April 2018, on the first "Traditional Chinese Garment Day", young Chinese don ancient finery to demonstrate "cultural confidence" to the world.

3) As he shares his story, the slight, bespectacled teenager is wearing robes of lilac and white, embroidered with blue clouds, an outfit he says is Jin-dynasty day-wear.

4) On this sunny festival weekend, a local Starbucks boasts baristas in toga-like robes, a warrior in chain-mail queuing for coffee, and outside, a Taoist priest in a tunic and cloak outfit he calls "a bit of messed-up fusion".

5) The clothing culture accumulated by Hanfu for thousands of years has strengthened young people's love for traditional culture and their pride in their own ownership.

2. Translate the following sentences into English.

1) 近年来，穿汉服已然成为一种风潮。在大街小巷、公园景区，总能看到衣袂飘飘的汉服爱好者。

2) 今年七夕节期间，合肥、昆明、石家庄等地纷纷举行汉服主题活动，把七夕民俗与汉服演绎结合在一起，原汁原味地展现传统文化。

3) 年轻人开始关注和选择中国传统服饰，并以之为美和新潮。这不仅是因为汉服本身的古风古韵，背后更多的是因为国人文化自信的回归。

4) 汉服是当今众多服装中的选择之一，就像西服、旗袍、中山装一样。在很多国家，如日本、韩国，传统的和服、韩服与西服的并用与融合都非常自然。

5) 汉服风潮的背后，一个新兴的文化消费市场正在快速成长。近三年来，汉服市场呈现爆发式增长。

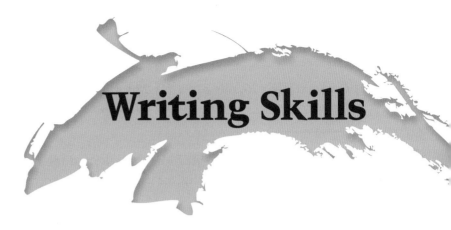

Writing Skills

Writing a Letter of Complaint

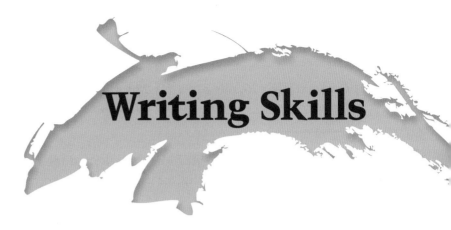

Part I Preparation

Task 1 Introduction

A letter of complaint is a type of formal letter that contains a complaint addressing an offense, grievance, unfair procedures, poor quality of goods, etc. A letter of this nature helps in presenting the misconduct in a formal way and focusing on resolving the issue.

The structure of a letter of complaint includes three distinct parts:

- an introduction that clearly identifies the subject of the complaint;
- a body that clearly and specifically explains the nature of the complaint, and provides the reader with all of the information needed to provide an appropriate response;
- a conclusion that clearly states what actions are needed to remedy the problem and that a prompt reply is requested.

Task 2 Preparation Task

The following sentences are from a letter of complaint. Fill in the blanks with appropriate words given in the box.

suffered	settled	investigation	regret	promptly
damage	reply	responsible	soiled	dissatisfaction

1) I am writing to express my _____ with the sweaters we ordered from you.

2) On September 10, our order for 280 women's cotton sweaters was duly received, but we _____ to say that 40 cotton sweaters in white color were seriously _____.

3) We had the case investigated immediately, and the result shows the _____ was due to improper packing, for which the suppliers are definitely _____.

4) Needless to say, we have _____ a great loss from this, as we cannot sell the sweaters in this condition to our customers.

5) We ask you to conduct _____ at your end and _____ to us _____.

6) We would like to have this matter _____ within 14 days.

Part II Reading Example

A Letter of Complaint About a Coat

Dear Sir/Madam,

I am writing to inform you of my complaint about the coat I ordered on your shopping web.

First, the coat was scheduled to arrive last Friday, but to my disappointment, I did not receive it until this Monday afternoon. What is worse, I found that the coat did not meet my order requirements. What I ordered was a black one, but I got a grey one. And besides that, the size of the coat that I ordered is XXL, but what I received is L. Although I tried my best to put it on, it is too small for me. As a matter of fact, the delay of delivery, the wrong color and improper size have caused too much inconvenience to me, which led me to miss an important party to attend, and even my boyfriend felt angry with me because of my absence from the party.

Your company has always enjoyed an excellent reputation among customers and that is why I decided to make purchase on your shopping web. But now I want to make my purchase to be delivered to you by mail or by a delivery service, and I don't want to buy my coat from your shopping web any more. Here I demand a refund and your explanations for the unpleasant service you have provided.

I am looking forward to your prompt reply, especially your addresses.

Yours sincerely,

Li Hong

Tips

- Give the reasons for complaint.
- Express your requests.
- Ask for a prompt reply.
- Address somebody at the beginning and give your name in the end.

Part III Task

Suppose you have received your pay for your summer holiday part-time job, but your pay is less than you were promised. Please write a letter of complaint to the manager, clearly stating what work you have done and how long your work took. While explaining your case, put forward your demand and suggestion. Your writing should be no more than 250 words.

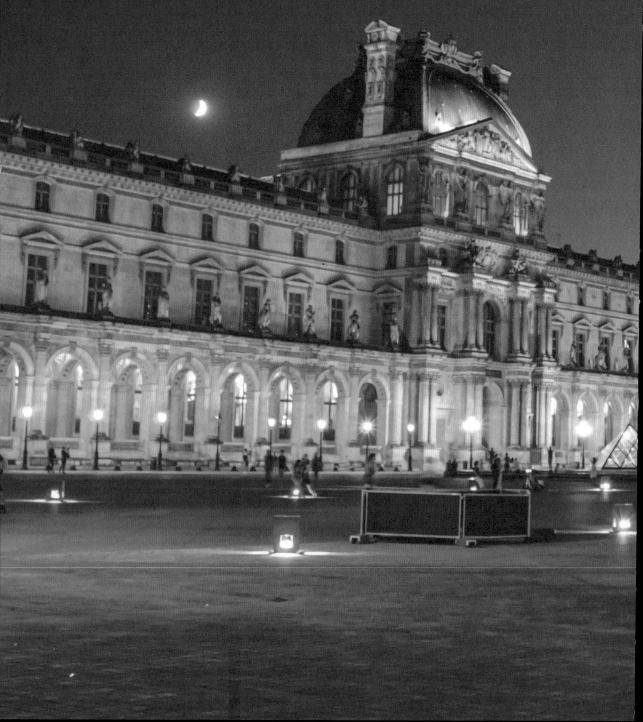

Learning Objectives

Students will be able to:

- understand and learn the vocabulary of architecture;
- know the stories of famous architects;
- appreciate the contributions of great architects;
- write a CV.

Unit **8**

Architecture
Masters

Lead-In

Task 1 Exploring the Theme

Look at the pictures and answer the questions.

What are the two buildings? Who designed them?

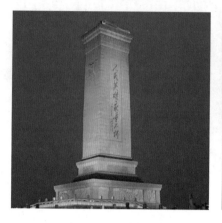 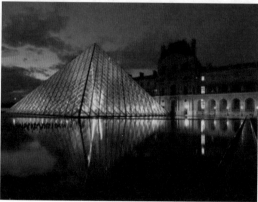

Task 2 Brainstorming

Answer the following questions.

1) What designing philosophy is respectively embodied in the two buildings?

2) Apart from these buildings, do you know any other important buildings designed by these two architects?

Task 3 Building Vocabulary

Talk with your classmates, and try to describe the following phrases in English.

architectural aesthetics	building maintenance	architectural history
building diagnosis	top daylighting	

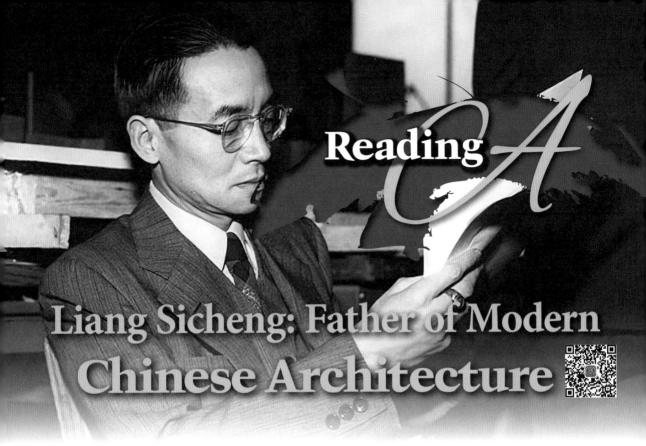

Reading A

Liang Sicheng: Father of Modern Chinese Architecture

1　Liang Sicheng[1] was born in Tokyo, Japan, where his father Liang Qichao[2] was in **exile** from China after the failed Hundred Days' Reform[3]. In 1911, he returned to China with his father.

exile *n.* 流亡；流放

2　In 1915, Liang entered Tsinghua College[4], a **preparatory school** for students to be sent by the government to study in the United States. In 1924, he went to University of Pennsylvania to study architecture. Three years later, Liang received his master's degree in architecture.

preparatory school 预备学校

3　When Liang Sicheng went back in 1928, he was invited by the Northeastern University in Shenyang. He established the second School of Architecture in China, and took the **curriculum** from University of Pennsylvania as its model. In 1946, Liang was able to practice his professorship in Tsinghua University in Beijing. This time a more **systematic**

curriculum *n.* 课程

systematic *adj.* 系统的

1　梁思成 (1901–1972)，建筑历史学家、建筑教育家和建筑师，被誉为中国近代建筑之父。

2　梁启超 (1873–1929)，中国近代思想家、政治家、教育家、史学家、文学家，戊戌变法领袖之一。

3　戊戌变法，也叫百日维新，于 1898 年 6 月 11 日开始。

4　清华学校，初名清华学堂。

professional *adj.* 专业的

reference *n.* 参考（书）

contemporary *adj.* 当代的；同时代的

zone *v.* 将……分成区（或划成带）

finance *n.* 财政；金融

municipal *adj.* 市政的

interpret *v.* 解释；诠释；口译

convey *v.* 表达；传达

illiterate *adj.* 文盲的；目不识丁的

orally *adv.* 口头地

decode *v.* 译解；解码

manual *n.* 手稿；手册；说明书

term *v.* 把……称为；把……叫作

timber-frame 木质结构

fundamental *adj.* 基本的；基础的

verify *v.* 证实；检验

assumption *n.* 假设

successively *adv.* 连续；先后

survive *v.* 幸存

curriculum was put forward, including courses of fine arts, theory, history, science, and **professional** practice. This has become a **reference** for any other school of architecture later developed in China.

4 In 1929, Liang and his colleague, Zhang Rui[1], at Northeast University won an award of the physical plan of Tianjin. This plan absorbs the **contemporary** American techniques in **zoning**, public administration, government **finance** and **municipal** engineering.

5 In 1931 Liang became a member of a newly-developed organization in Beijing called the Institute for Research in Chinese Architecture. He felt a strong impulse to study Chinese traditional architecture and that it was his responsibility to **interpret** and **convey** its building methods. It was not an easy task. Since the carpenters were generally **illiterate**, methods of construction were usually taught **orally** from master to apprentice, and were regarded as secrets within every craft. In spite of these difficulties, Liang started his research by "**decoding**" classical **manuals** and consulting the workmen who have the traditional skills.

6 As an architectural historian, Liang was determined to search and discover what he **termed** the "grammar" of Chinese architecture. He recognized that throughout China's history the **timber-frame** had been the **fundamental** form of construction. He also realized that it was far from enough just to sit in his office day and night engaged in the books. He had to get out searching for the surviving buildings in order to **verify** his **assumptions**. His first travel was in April 1932. In the following years he and his colleagues **successively** discovered some **survived** traditional buildings, including: the Temple of

1 张锐，梁思成清华学校校友，1930 年两人合作完成《天津特别市物质规划方案》。

Buddha's Light[1] (857), the Temple of **Solitary** Joy[2] (984), the Yingzhou **Pagoda**[3] (1056), Zhaozhou Bridge[4] (589–617), and many others. Because of their effort, these buildings managed to survive.

solitary *adj.* 孤独的；孤单的

pagoda *n.* 塔

7 After the Second World War, Liang was invited to establish the architectural and **urban** planning programs at Tsinghua University. In 1946, he went to Princeton University as a visiting fellow and served as the Chinese representative in the design of the United Nations Headquarters Building. In 1947, Liang received an **honorary** doctoral degree from Princeton University.

urban *adj.* 城市的；城镇的

honorary *adj.* 名誉的；荣誉的

8 In 1949, Liang was given the responsibility to develop a national style of architecture by the Communist Party of China, and his aim was to pass on the essence of Chinese architecture. This specific "essence", was considered to be the "large roof", the temple-style **concave curved** roofs and **overhanging eaves** to **denote** their Chinese origin.

concave curved 凹曲（面）的

overhang *v.* 悬垂
eave *n.* 屋檐
denote *v.* （符号等）代表

9 With a deep respect for tradition and the nation's cultural **heritage**, Liang **came up with** his biggest ambition: **preserving** Old Beijing. The capital city of both the Ming (1368–1644) and Qing (1644–1911) dynasties, Beijing had 20 gates in the walls of the outer city, the inner city and the **imperial** city. In the 1950s, a debate started among scholars, politicians and historians as to whether these city walls and gates should be kept. Liang Sicheng was a leading **advocate** to save them. However, Liang and his fellows failed to persuade the authorities, and the structures were torn down to make way for urban construction in Beijing.

heritage *n.* 遗产；传统
come up with 想出；提出
preserve *v.* 保护；维护
imperial *adj.* 皇家的；帝国的
advocate *n.* 提倡者；倡议者

1 佛光寺，位于山西省五台县，始建于北魏孝文帝时期（471—499 年），唐大中十一年（857 年）重建。
2 独乐寺，又称大佛寺，位于中国天津市蓟州区，984 年重建，是中国仅存的三大辽代寺院之一，也是中国现存著名的古代建筑之一。
3 应州塔，俗称应县木塔，建于辽清宁二年（1056 年），金明昌六年（1195 年）增修完毕。是我国现存最高最古的一座木构塔式建筑，也是唯一一座木结构楼阁式塔。
4 赵州桥，始建于隋代 (589–617)，位于河北省石家庄市赵县，是世界上现存年代久远、跨度最大、保存最完整的单孔坦弧敞肩石拱桥。

10 He was the Chinese representative on the 11-person team that designed the United Nations Headquarters in New York City. In around 1950, he and his wife, Lin Huiyin[1], were both **appointed** to the groups designing the new national **emblem**. In 1951, they were commissioned to design the Monument to the People's Heroes.

appoint *v.* 任命；委派

emblem *n.* （代表国家或组织的）徽章；象征

11 Liang is the author of China's first modern history on Chinese architecture and is recognized as the "Father of Modern Chinese Architecture". To cite Princeton University, he was "a creative architect who has also been a teacher of architectural history, a pioneer in historical research and exploration in Chinese architecture and planning, and a leader in the restoration and preservation of the **priceless** monuments of his country".

priceless *adj.* 无价的；极其珍贵的

(757 words)

(From China Daily website, China Institute website and INFOGALACTIC website.)

1 林徽因（1904–1955），梁思成夫人，中国著名的建筑学家、作家，中国第一位女性建筑学家。

Part I Understanding the Text

Task 1 Global Understanding

1. Read the text and identify the main idea.

1) According to the text, what contributions did Liang Sicheng make to New China?

2) This text is organized in chronological order. Can you complete the following information?

Year	Event	Year	Event
In 1901	Born	In 1931	
In 1911		In 1946	
In 1924		In 1947	
In 1928		In 1949	
In 1929		In 1951	

2. Read the text and decide whether the following sentences are true (T) or false (F).

() **1)** When Liang Sicheng was born, his father was studying in Japan.

() **2)** Liang Sicheng went to study in the United States and got his master's degree.

() **3)** After he went back to China, Liang Sicheng established the first School of Architecture in China.

() **4)** Liang Sicheng succeeded in persuading the authorities in protecting the traditional buildings in Beijing.

() **5)** Liang Sicheng's achievement in architecture is of great influence at home and abroad.

Task 2 Detailed Understanding

1. Read the text again and choose the best answer to each question below.

1) Where did Liang Sicheng study architecture?

 A. Japan.

 C. The United States.

 B. Tsinghua College.

 D. Northeastern University.

2) What is NOT mentioned in the curriculum in Tsinghua University in 1946?

 A. Fine arts.

 C. Science.

 B. History.

 D. Physical Education.

3) Why was it a difficult task for Liang Sicheng's team to convey the Chinese traditional building methods?

 A. Because the buildings were very old.

 B. Because the structures were complicated.

 C. Because the buildings were badly ruined.

 D. Because there were no written blueprints.

2. Answer the following questions according to the text.

1) How did Liang Sicheng start his research on Chinese traditional architecture?

2) What did Liang Sicheng and his colleagues do in order to verify his assumptions?

3) According to the text, what are Liang Sicheng's famous designs?

Task 1 Key Terms

The following words or phrases are related to architecture. Discuss with your classmates and provide your understanding about each term in English.

1) municipal engineering: _____

2) inner city: _____

3) apprentice: _____

4) urban planning: _____

5) temple-style: _____

6) overhanging eaves: _____

7) outer city: _____

8) cultural heritage: _____

9) imperial city: _____

10) national emblem: _____

11) restoration: _____

12) preservation: _____

13) urban construction : _____

14) concave curved roof: _____

15) timber-frame: _____

Task 2 Vocabulary

Choose the correct word from the box below to complete each of the following sentences. Change the form where necessary.

preparatory	curriculum	finance	reference	municipal
honorary	illiterate	interpret	preserve	verify
assumption	heritage	essence	advocate	appoint

1) Her evidence suggests a different _____ of the events.

2) Whether this solution is effective remains to be _____ .

3) An acute observer usually sees the _____ of things at first sight.

4) At least a year's _____ work will be necessary before building can start.

5) All the schools have music and dancing as part of the _____ .

6) We are working on the _____ that it was a gas explosion.

7) His _____ and research on traditional buildings have profound influence.

8) There are several _____ books which have been compiled to help you make your choice.

9) The _____ government is going to provide funds for this construction project.

10) _____ is a major problem in some developing countries.

11) We must make the most efficient use of the available _____ resources.

12) He has received many _____ for his research into cancer.

13) The paintings were in an excellent state of _____ .

14) People are gradually realizing the importance of preserving national _____ .

15) They _____ a new manager to coordinate the work of the team.

Part III Translation

1. Translate the following sentences into Chinese.

1) In 1924, he went to University of Pennsylvania to study architecture. Three years later, Liang Sicheng received his master's degree in architecture.

2) This plan absorbs the contemporary American techniques in zoning, public administration, government finance and municipal engineering.

3) In spite of these difficulties, Liang Sicheng started his research by "decoding" classical manuals and consulting the workmen who have the traditional skills.

4) In the 1950s, a debate started among scholars, politicians and historians as to whether these city walls and gates should be kept. Liang Sicheng was a leading advocate to save them.

5) He was "a creative architect who has also been a teacher of architectural history, a pioneer in historical research and exploration in Chinese architecture and planning, and a leader in the restoration and preservation of the priceless monuments of his country".

2. Translate the following sentences into English.

1) 他有一种强烈的冲动去研究中国传统建筑。

2) 建筑艺术是中国文化的重要载体。

3) 这部纪录片向观众展示了中国现代建筑的发展和建筑文化的演变。

4) 怀着对传统和民族文化遗产的深切尊重，梁思成提出了他最大的愿望：保护老北京。

5) 这几位建筑大师为保护历史文化名城、传承中国建筑做出了突出贡献。

Reading B

Architect of Bold Designs

1 I. M. Pei[1], the man who designed some of the most **iconic** modernist structures in China and elsewhere, passed away at age of 102, on May 16, 2019. Lee Ho-yin[2] remembers his brief, **illuminating** encounters with the legendary architect.

2 I have been asked what influence the modernist architect, Ieoh Ming Pei, had on contemporary architecture. I could probably fall back on my experience as an educator in architectural design and architectural conservation to come up with an answer. However, I think my personal encounters with the master and his works during my **formative** years as an architecture student would make for a better and more sincere response.

3 My first indirect encounter with Pei happened when I was a sophomore at the School of Architecture at the National University of Singapore[3]. This was in the early 1980s, an era

iconic *adj.* 标志性的；图标的

illuminating *adj.* 富于启发性的

formative *adj.* （对某事物或某人性格的发展）有持续重大影响的

1 贝聿铭 (1917–2019)，美籍华人建筑师，美国艺术与科学院院士，中国工程院外籍院士，土木专家。

2 李浩然，香港大学建筑保护项目负责人。

3 新加坡国立大学。

prevailing *adj.* 盛行的；普遍的

drab-looking 单调的；毫无生机的

irrelevant *adj.* 无关的

facade *n.* 外表；建筑物的正面

of aesthetic excess as reflected in the **prevailing** disco culture and postmodern architecture. One day, a professor introduced Pei's first piece of work in the city state, the OCBC Centre[1], completed in 1976. Typical of sophomores who tend to favor style over substance, I was not particularly impressed by what appeared to be a rather unremarkable—and **drab-looking**—office tower. The only lesson that stuck in my clueless mind was an **irrelevant** side-story that, whether by coincidence or design, the **facade** of the building resembled the Chinese character denoting the architect's surname.

obsolescence *n.* 陈旧；老化；过时

4 It was around the same time that the ambitious Raffles City project[2]—of which Pei was the chief architect—had successfully lifted Singapore's status from Third World urban **obsolescence** to First World modernity. Completed in 1986, the project included the world's tallest hotel and the city's largest shopping mall. By the time it opened in the late 1980s, I was more knowledgeable in architecture, having completed the first of a two-degree program and a year-long intensive **internship** with two architectural firms in Hong Kong, China.

internship *n.* 实习

spacious *adj.* 宽敞的；广阔的

atrium *n.* （现代建筑物中央通常带有玻璃屋顶的）中庭；中厅

be blown away 使印象深刻

immerse *v.* 沉浸；浸泡

crisscrossing *adj.* 交叉的

drum into 反复地讲；灌输

immersive *adj.* 沉浸式的

5 I remember visiting the mall's **spacious atrium** with my classmates and **being blown away** by what I saw. It was like being **immersed** in a space that came alive with **crisscrossing** shoppers on the ground, along the open corridors, and on the bridge spanning the atrium. For the first time I got a sense of Pei's subtle genius and realized what my professors had been trying to **drum into** my head about creating spaces that would produce a memorable **immersive** experience.

Culture in Architecture

6 Toward the end of my studies, I had my first direct encounter with the master architect when he came to lecture in our school. As expected, Pei's lecture in the school's largest lecture theater was filled to capacity.

1　华侨银行大厦，由贝聿铭设计，曾经是新加坡及东南亚最高的摩天大厦。
2　来福士城项目。

7 Pei talked about his first project in China, Fragrant Hill Hotel[1] in Beijing (completed in 1982). He spoke of his struggle to **incorporate** cultural relevance in the **wantonly** neutral style of modernism. To accomplish this, as he explained, the architecture had to **be infused with** cultural familiarity. This was achieved by using abstract Chinese decorative features, and applying the Chinese concept of "borrowed landscape" through framing outdoor landscape scenes with windows and wall openings to form living landscape paintings. No wonder the hotel has become a timeless masterpiece by giving people the experience of physical as well as cultural space.

incorporate *v.* 包含；吸收

wantonly *adv.* 肆意地；放任地

be infused with 使具有；充满

8 During the question-and-answer time after his talk, I could not **resist the temptation** of asking him if there was any truth to the facade of the OCBC Centre being a giant pronouncement of his surname.

resist the temptation 抵制诱惑

9 Pei gave a **bemused chuckle**, and said that it was no more than an urban legend. "I am not that **egoistic**," he replied, "but that is a great story to tell people."

bemused *adj.* 困惑的；茫然的

chuckle *n./v.* 轻轻笑

egoistic *adj.* 自私自利的

Banking on Humor

10 In the 1990s, after my **stint** as an architectural designer in several firms, I left Singapore for doctoral studies at The University of Hong Kong. That was when I had my second direct encounter with Pei, when he came to the university to give a talk. At this talk, I learned how Pei was able to use his wits to **reverse** a seemingly lost situation.

stint *n.* 从事某项工作（或活动）的时间

reverse *v.* 扭转

11 The first story relates to the Bank of China Tower[2] in Hong Kong (completed in 1990) which stands today as one of the city's most iconic **landmarks**. As with many of his projects, things didn't go smoothly due to the groundbreaking nature of his architectural concepts. The board of directors reacted badly to his design, complaining about the X-shaped structural frames on the building, "You know, we are an important bank, and it doesn't inspire confidence to see a series of Xs all over our headquarters!"

landmark *n.* 地标；路标

1 香山饭店，位于北京。

2 香港中银大厦。

12 "Crosses? What crosses? Those are stacks of diamonds!" Pei had told them. He wore his trademark Cheshire Cat smile[1] as he narrated the incident to us.

13 Needless to add, the Bank of China directors approved the design.

14 The second story is about the Louvre Pyramid[2] in Paris, completed in 1989. In his persistence for quality, Pei wanted near 100 percent **transparency** in the glass used to build the pyramid. This meant that the material had to be of **optical** glass quality. But the French glass makers said this was impossible— the best they could come up with was a 90 percent transparency. Not willing to compromise, Pei ran a search and found that there were glass makers in Germany who could achieve his desired standard. Armed with this information, he went back to Paris, and let it be known that he was considering giving the job to German glass makers. Out of national pride, the French government hurriedly assured him that they would try to match whatever the Germans could do.

transparency *n.* 透明度
optical *adj.* 光学的

15 Pei's design for the Louvre Pyramid was **panned** in France and by architects the world over. Back then, it was a near-taboo to attach a modern design to an important historic monument. Yet 30 years on, the once universally hated glass pyramid has become a much-treasured modern monument as people came to appreciate how the new architecture has refreshed the otherwise frozen history of the Louvre.

pan *v.* 严厉批评

16 Today, I often say to my students, "Look around Hong Kong at some of the **Revitalization** Scheme projects[3], and you will see the subtle but long-lasting influence of the master I. M. Pei."

revitalization *n.* 复苏；振兴

(1027 words)

(From China Daily website.)

1 柴郡猫笑，形容咧着嘴笑。
2 卢浮宫金字塔。
3 香港"活化历史建筑伙伴计划"。

Part I Understanding the Text

Task 1 Global Understanding

1. Read the text and identify the main ideas.

1) What did the author think of his first indirect encounter with Mr. Pei?

2) When did the author get Mr. Pei's talent in architecture?

2. Write down the key ideas of each paragraph below.

Paragraph 7: _____

Paragraph 11: _____

Paragraph 14: _____

Task 2 Detailed Understanding

1. Answer the following questions according to the text.

1) What was the Raffles City project?

2) What did the author do during the question-and-answer time after Mr. Pei's talk in the author's school?

3) Why did the Bank of China directors finally approve Mr. Pei's design?

2. Discuss the following questions with your partner.

1) How did Mr. Pei achieve his idea of cultural familiarity in designing the Fragrant Hill Hotel?

2) What does the author mean by mentioning Mr. Pei's "Cheshire Cat smile" in Paragraph 12?

3) Use several words to describe the author's comments on Mr. Pei.

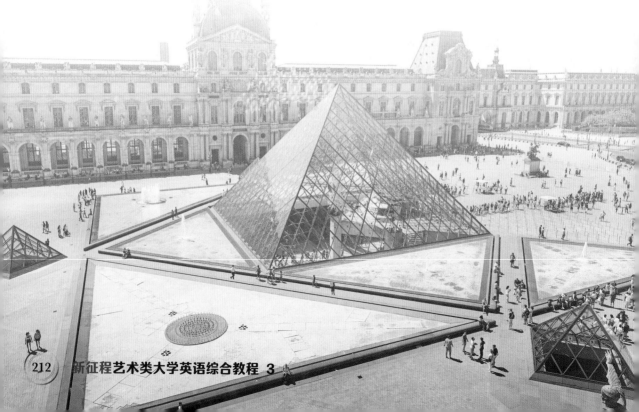

Part II Building Language

Task 1 Key Terms

The following words or phrases are related to architecture. Discuss with your classmates and provide your understanding about each term in English.

1) architectural design: _____

2) architectural conservation: _____

3) postmodern: _____

4) facade: _____

5) shopping mall: _____

6) spacious atrium: _____

7) open corridor: _____

8) landmark: _____

9) transparency : _____

10) monument: _____

11) optical glass: _____

Task 2 Vocabulary

Match the definitions on the right with the words on the left.

1) illuminating **A** the front of a building

2) prevailing **B** to include sth. so that it forms a part of sth.

3) irrelevant **C** to change sth. completely so that it is the opposite of what it was before

4) facade **D** of or relating to or involving light or optics

5) incorporate **E** helping to make sth. clear or easier to understand

6) reverse **F** the state of becoming old-fashioned and no longer useful

7) optical **G** not important to or connected with a situation

8) egoistic **H** existing or most common at a particular time

9) obsolescence **I** limited to or caring only about yourself and your own needs

Part III Translation

1. Translate the following sentences into Chinese.

1) I could probably fall back on my experience as an educator in architectural design and architectural conservation to come up with an answer.

2) This was in the early 1980s, an era of aesthetic excess as reflected in the prevailing disco culture and postmodern architecture.

3) I remember visiting the mall's spacious atrium with my classmates and being blown away by what I saw.

4) No wonder the hotel has become a timeless masterpiece by giving people the experience of physical as well as cultural space.

5) As with many of his projects, things didn't go smoothly due to the groundbreaking nature of his architectural concepts.

2. Translate the following sentences into English.

1) 1983 年贝聿铭获得普利兹克建筑奖 (Pritzker Prize)，该奖被誉为"建筑界的诺贝尔奖"。

2) 不出所料，贝聿铭在学校最大演讲厅的演讲座无虚席。

3) 《百年巨匠》(Century Masters) 是中国第一部以 20 世纪杰出大师为题材的大型传记纪录片系列。

4) 与会者建议，中国设计师应将传统文化与现代风格相结合，将中国风格与西方风格相结合。

5) 这对建筑师夫妇认为，人们应该找到新颖的方法，将中国古典艺术的精髓融入工业设计。

Writing Skills

Writing a Curriculum Vitae (CV)

Part I **Preparation**

Task 1 Introduction

Curriculum Vitae (CV) means "course of life" in Latin, and that is just what it is. A CV is a concise document which summarizes your past, existing professional skills, proficiency and experiences. The purpose of this document is to demonstrate that you have the necessary skills (and some complementary ones) to do the job for which you are applying. Literally you are selling your talents, skills, proficiencies, etc.

Task 2 Preparation Task

Fill in the blanks with the correct words from the box.

> further from undertaken responsibility in career hands-on

As a recent graduate 1) _____ University of XXX, with Bachelor degree 2) _____ Architecture, I have 3) _____ internships at XXX. These placements have allowed me to develop sector knowledge and gain 4) _____ experience, as well as expand transferable skills such as designing, display and constructive skills. My 5) _____ aim is to gain a role which allows me to 6) _____ my expertise and take on increased 7) _____ at a designing and decorative agency.

Part II Reading Example

Personal Information:

Name: Zhang San

Sex: Male

Date of Birth: Aug 15th, 1996

Place of Birth: Guangzhou City, Guangdong Province, P. R. China

Marital Status: Single

Health: Good

Mobile :13900000000

E-mail: wdjlw@www.wdjlw.cn

Objective:

Designer; Decoration Assistant

Educational Qualifications:

2015.9–2019.7 Bachelor of Engineering, Chongqing University

Major Subjects: Principles of Architectural Composition; Civil Engineering Materials; Building Structure; History of Chinese Architecture; Esthetic of Architecture; Interior Design; Architecture Design

Work Experiences:

2003. 7–Present Guanzhou Design Institute as an assistant engineer, involving pre-design programming, conducting project proposal, drawing construction, etc.

Special Skills

1. Language Skills:

 Fluent Cantonese

 Mandarin certificate (the Second Level Grade A)

 CET 6, being able to communicate in fluent English

2. Computer Skills: National Computer Rank Examination, Rank II

3. Other Skills: Driving license

Awards:

National Scholarship 3 times

Second Prize in Interior Design in Chongqing

Grand Prize in National English Competition for College Students

First Prize in 100 meters' dash in school sports meeting

Hobbies:

Basketball; playing the guitar

Profile / Personal Statement / Highlights:

As a recent graduate from Chongqing University, with a bachelor's degree in Architecture, I am proficient in Cantonese, Mandarin and English; know how to use various computer software for designing and handling documents. I am able to communicate with people from all walks of life. I have undertaken internships in Guangzhou Design Institute for six months. These placements have allowed me to develop sector knowledge and gain hands-on experience, as well as expand transferable skills such as designing and constructive skills. My career aim is to gain a role which allows me to further my expertise and take on increased responsibilities at a designing and decorative agency.

Tips

- Do some research about the job industry before writing your CV.
- Include the skills that are relevant to the job you are applying for.
- Include any achievements relevant to the job industry.
- Highlight any training or professional development undertaken.

Part III Task

Assume that you are a senior student, and you are going to apply for a job in XXX construction company. Write your CV in a proficient way as much as possible.